BIRMINGHAM NEW STREET STATION

THROUGH TIME

Mark Norton

AMBERLEY

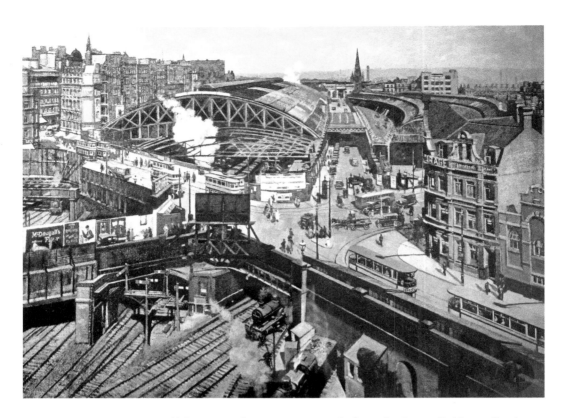

New Street Station *c*. 1930. (Oil painting by A. L. Hammonds from the Bryan Holden collection ©
Roseworld Productions Limited 2013)

First published 2013

Amberley Publishing
The Hill, Stroud
Gloucestershire, GL5 4EP

www.amberley-books.com

Copyright © Mark Norton, 2013

The right of Mark Norton to be identified as the
Author of this work has been asserted in accordance
with the Copyrights, Designs and Patents Act 1988.

ISBN 978 1 4456 1095 5

British Library Cataloguing in Publication Data.
A catalogue record for this book is available from
the British Library.

Typeset in 9.5pt on 12pt Celeste.
Typesetting by Amberley Publishing.
Printed in the UK.

Introduction

In recent years, much has been written about St Pancras station, London. From a heritage viewpoint, its survival is an amazing story. But what of the history? It was opened in 1868, fell into decline, escaped demolition and was finally restored.

The history of New Street Station, Birmingham, could not provide a greater contrast. You will find it hard to find much evidence of the original station that opened in 1854, but the changes that have taken place over the years echo the type of changes that have affected the city whose transport network it sits at the heart of, and provides a rich and fascinating story.

Birmingham, the city with the motto 'Forward', seems to be in a constant state of redevelopment. As we shall see in the pages that follow, New Street Station has seen more than its fair share of remodelling over the years. And just like Birmingham itself, some of the work that was done, particularly in the 1960s, has been acknowledged as being a step backward rather than forward!

And so it goes on. At the time of writing, New Street Station is currently undergoing the biggest changes it has seen in the last 50 years. As part of the Gateway Plus project, by 2015, New Street Station should once again be something of which Brummies can be proud instead of ashamed.

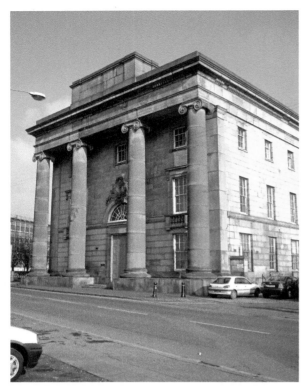

London & Birmingham Railway

Birmingham's first station was at Curzon Street. Designed by Philip Hardwick and opened in 1838, the original station building, complete with impressive Ionic columns, survives to this day and may become part of the HS2 terminus, should that project ever get off the drawing board.

The other end of the line was Euston, where a propylaeum known as the Euston arch was constructed in the Doric style. Tragically demolished in 1961/62, its loss would become a trigger for the expansion of the conservation movement in England.

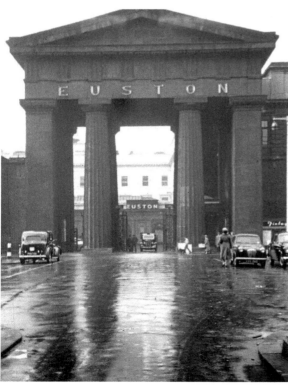

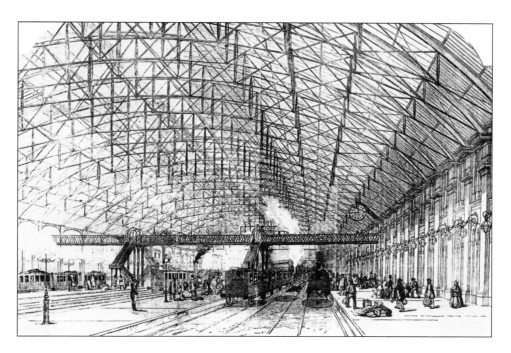

Grand Central Station

It soon became clear that a larger and more central station would be of benefit. An area of notorious slums was the ideal site and streets such as The Froggary, Peck Lane and King Street would make way for the new station, constructed by the London & North Western Railway company between 1847 and 1854.

The station building was designed by Edward Alfred Cowper and was officially opened on 1 June 1854, although trains had been operating since 1852. In news reports of the day, it was referred to as the 'Grand Central Station'.

Adjacent to the station, the Queen's Hotel, designed by William Livock, opened at the same time.

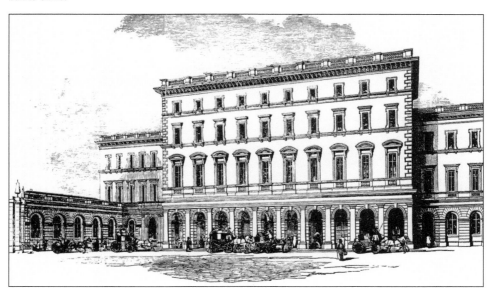

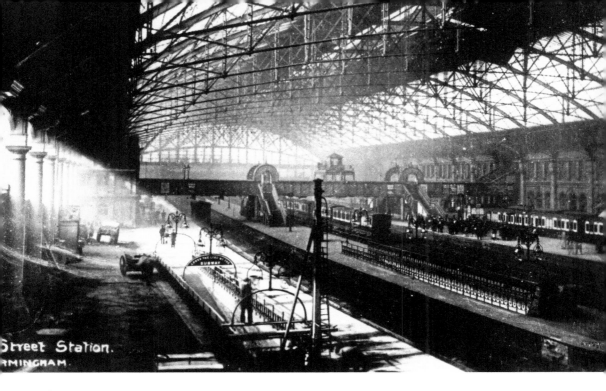

Street Station.
BIRMINGHAM.

Early Years

The station occupied a site of 7 acres and featured what was, at the time, the largest single span roof in the world. Measuring 840 feet long and 212 feet wide, it would retain this title until St Pancras opened in 1868.

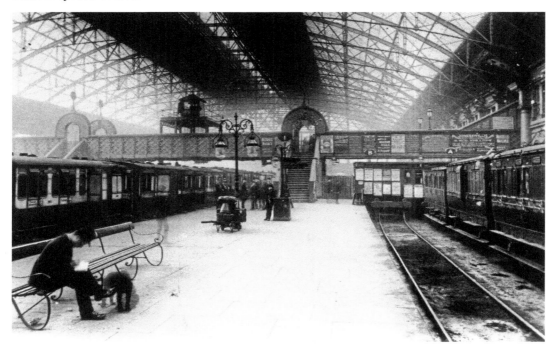

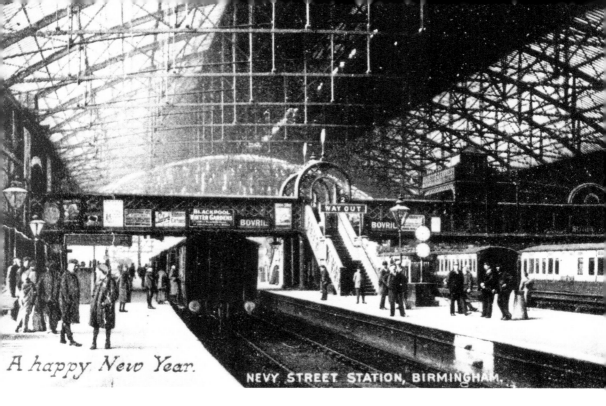

A happy New Year.

NEW STREET STATION, BIRMINGHAM.

An ancient public right of way cut through the site and was kept in place by means of the footbridge that crossed the station from Great Queen Street to Stephenson Street. As a result, New Street was an 'open' station and tickets were not checked, a practice that continued right up until the 1960s.

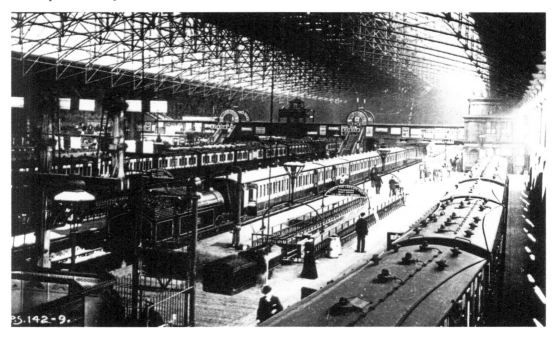

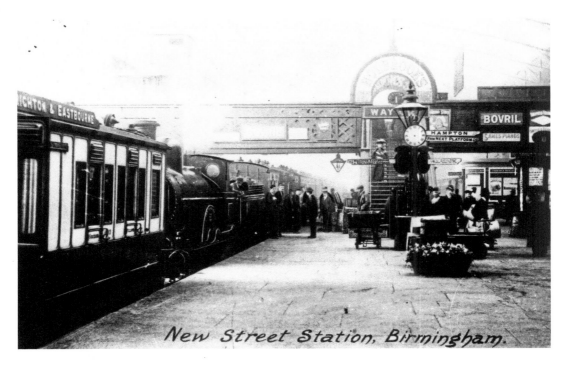

New Street Station, Birmingham.

Platform numbers did not follow modern conventions. Access from the footbridge took the passenger to platforms 1, 2 and 3. They would then require knowledge of which side of the platform their train could be found. The scene above shows a train for Brighton and Eastbourne on the south side of platform 1. For trains to nearby Hampton, the north side of the platform was used.

Below, locomotive number 1816 stands in the central road between platform 1 and 2.

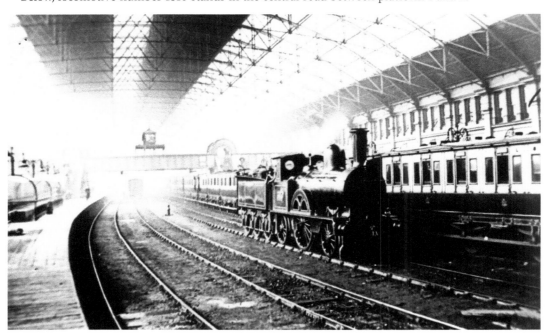

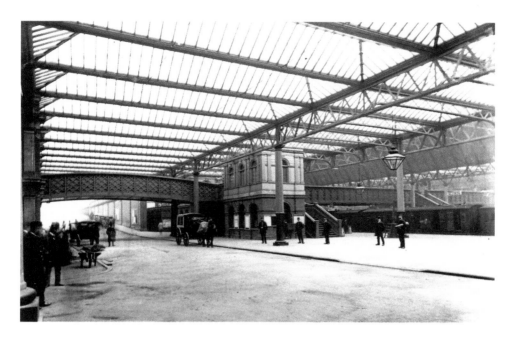

Midland Railway Expansion

The Midland Railway company had used the L&NWR station from its opening. This quickly became limiting so, on 8 February 1885, the company opened an extension to New Street on the south side of Great Queen Street, bounded by Hill Street and the newly created Station Street. With this, New Street Station became the largest in the Britain.

Above, the footbridge through the station now extends into the Midland side of the station. Below, the scene from the new platform 4, with platform 5 to the right. Two smaller roofs covered the new part of the station.

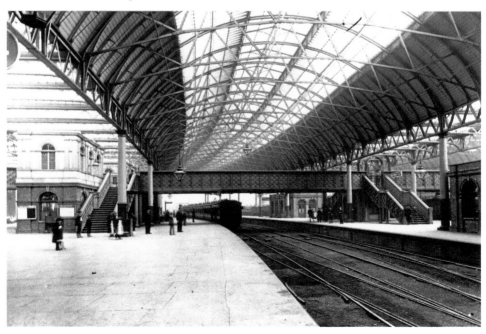

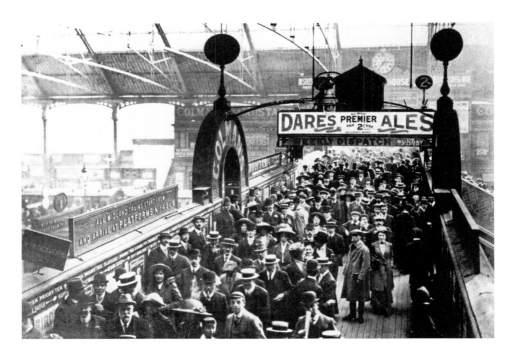

Footbridge

The original footbridge through the station had to be widened in 1874 and scene above clearly illustrates why this was so. There is a sign saying 'Blackpool' visible to the left. Perhaps that explains the crowds on this particular day?

Above the bridge, between platforms 1 and 2, lay a signal box. The signalmen are proudly posing for the much quieter view seen below.

Both pictures were taken from the Queen's Hotel, looking towards Great Queen Street and the Midland side of the station.

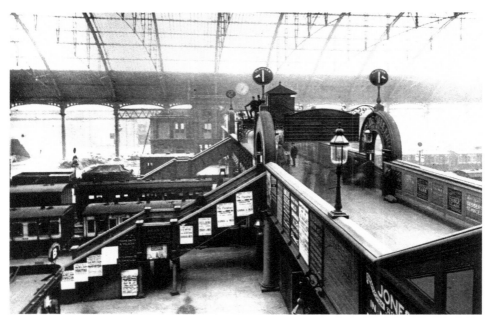

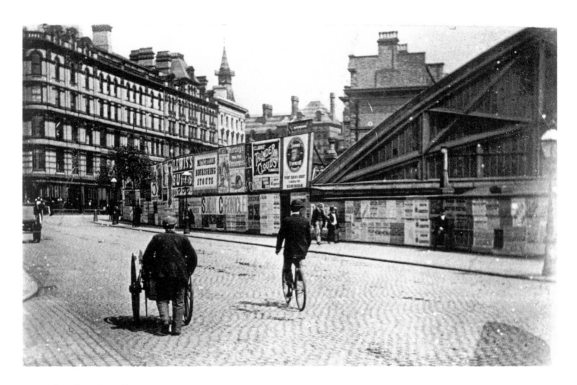

Station Exterior

The view of the cobbled Navigation Street, above, helps indicate the scale of the massive roof that covered the original part of the station. The buildings to the left still remain today. The Queen's Hotel rises above the arches of the station roof.

Below, a *c.* 1905 picture shows the entrance to Great Queen Street from Hill Street. Again, the scale of the roof of the northern half of the station is clearly illustrated.

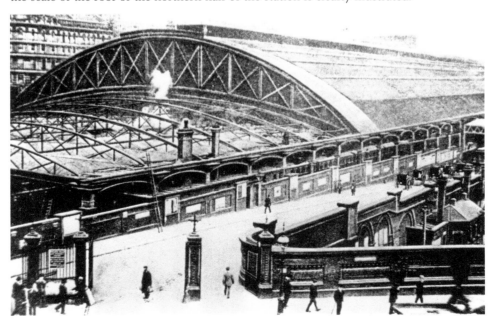

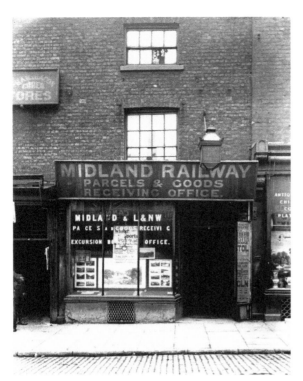

Supporting Offices

In the early part of the twentieth century, a station like New Street would be a hive of activity. These two offices, pictured in October 1908, provided facilities for dealing with parcels and for booking excursions.

Left, the office at 46 Snow Hill not only advertises trips to Yorkshire and Lancashire, but also winter sports trips to Switzerland in conjunction with Thomas Cook & Son.

The other office was located at The Parade and features a poster saying, 'Birmingham to Bournemouth via Bath 4 hrs 4 mins.'

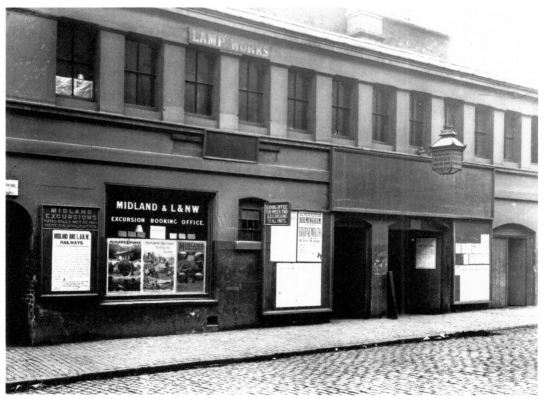

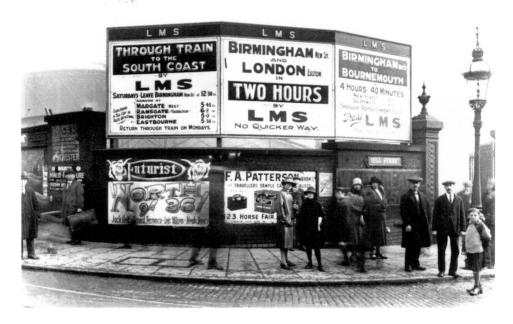

Post-Grouping

In 1923, many of the individual railway companies were amalgamated into what became known as 'The Big Four'. The London, Midland & Scottish Railway incorporated the L&NWR and Midland Railway companies. The advertising hoardings on Hill Street, pictured in the mid-1920s, show this new identity.

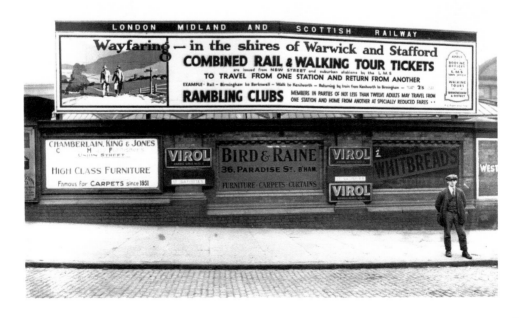

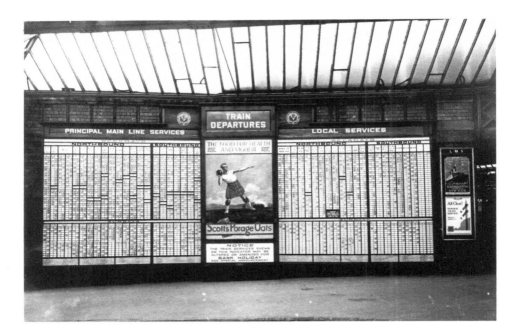

Station Street

The Station Street entrance, seen below in July 1929, featured an amazing departure board. On the left were the times for main line services such as Manchester and Liverpool. This was divided into weekdays at the top and Sundays at the bottom, and then further divided into northbound and southbound sections. On the right was a similar board for local services such as Perry Barr and Kings Norton.

At the bottom of the board was a notice that read, 'The train services shewn on this indicator may be altered or amended for Bank Holiday.' Apparently, 'shewn' is an old spelling of 'shown' so this was not a mistake.

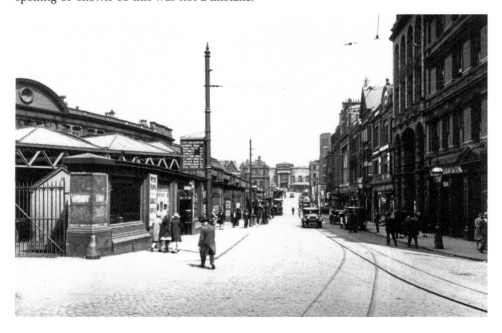

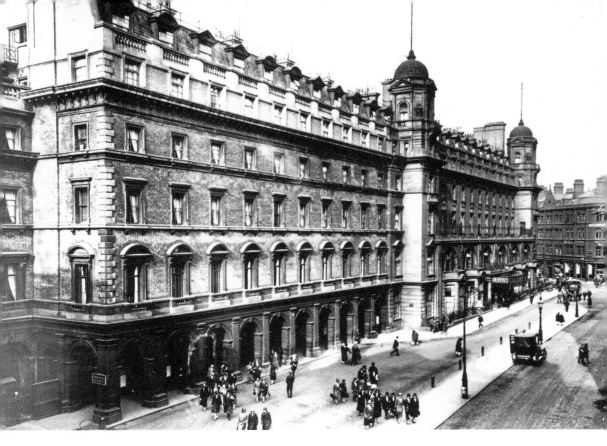

1920S

Right, this mid-1920s view of New Street Station clearly shows the split between the original station to the left and the Midland extension to the right. Taken from the rear of the Central Technical College on Suffolk Street, this photograph would provide the inspiration for the superb painting by local artist A. L. Hammonds seen on page 2.

Above is the Queen's Hotel. Demand had forced expansion of the building and a west wing was added in 1917, followed by two extra floors in the early 1920s. Compare with the view on page 5.

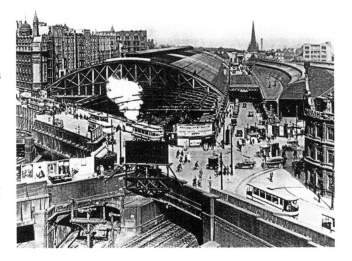

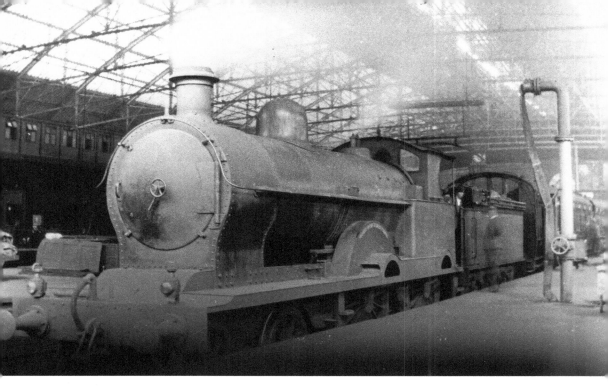

1930s

The station at work between the wars. Above, facilities for taking on water existed within the station itself, as seen to the right. Below, the driver and fireman on the tank engine are happy to pose for the photographer between shunting duties.

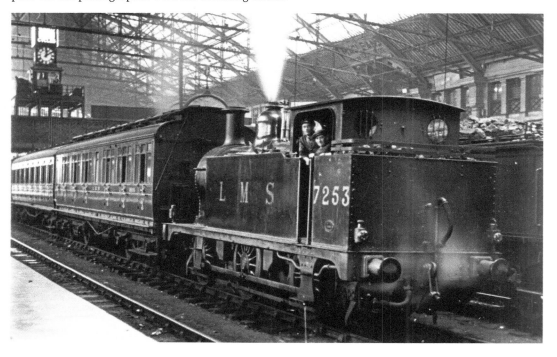

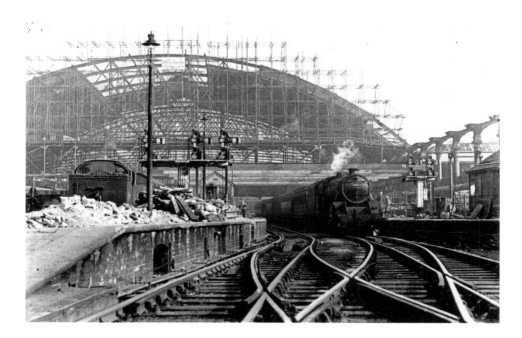

1940s

The single span roof, which had stood over the station since 1854, was damaged beyond repair during the bombing raids of the Second World War. These views from 1946 show the roof being removed. Above, the pillars to the right are supporting fresh air instead of metal beams. Below, the renumbered platforms 4 and 5 (previously platform 2) look little changed but will shortly lose much of their charm. At the same time, the old signal box will be removed.

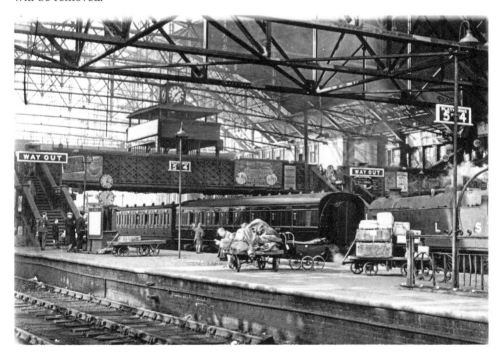

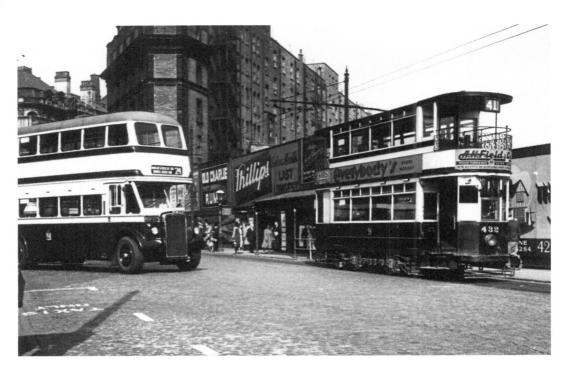

Connections to trams and buses were essential for the travellers using the station, as they are today. Above, Navigation Street sees a number 41 tram to Moseley Road tram depot and a number 24 bus to Warstock. Below, Hill Street, John Bright Street and Navigation Street are positively teaming with buses and trams in a picture taken from the top of the Queen's Hotel.

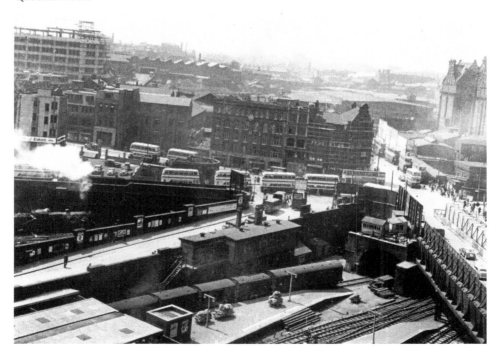

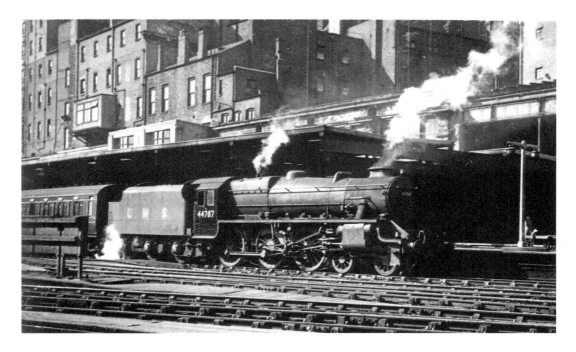

British Railways

On 1 January 1948, nationalisation of the railways took place and British Railways was formed. It would take quite a while for the old train company names to disappear given that the country was short of funds in the post-war austerity years.

Locomotives would also be renumbered to a new BR scheme and these two pictures, taken after the construction of a new awning roof, show freshly updated 44767 in April 1948 and 45509 in September 1949.

With the old roof removed, the rear of the Queen's Hotel now looms large over the northern half of the station.

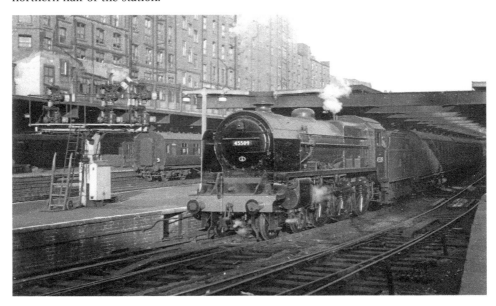

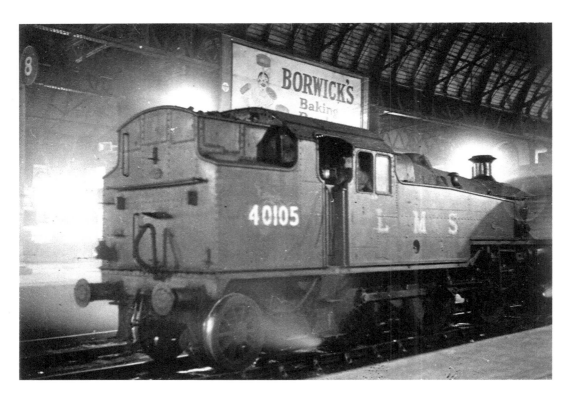

The southern half of the station survived the war pretty much unscathed and these two atmospheric photographs capture the area beautifully. Above, 40105 stands on the central road between platform 7 and 8 deep in the heart of the station. Below, 58261 sits on the same stretch of track but at the far western end, close to signal box 4, which can be seen above the coal tender.

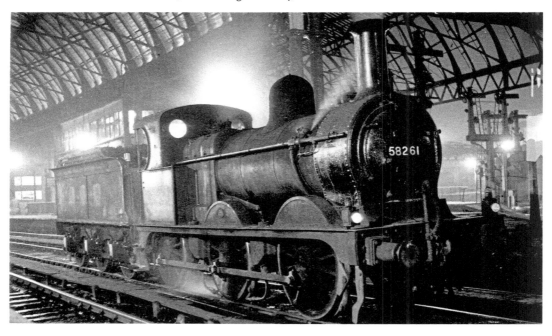

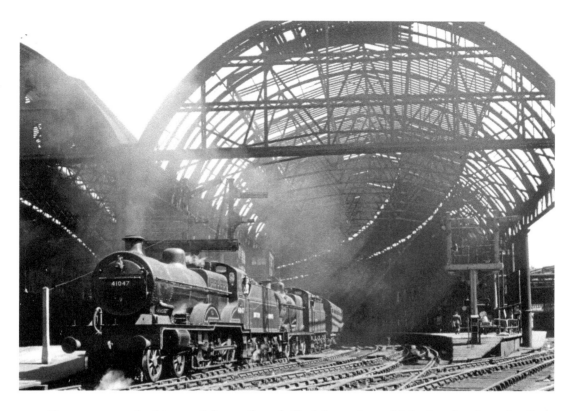

Two more superb pictures of the southern half of the station, with both trains departing from platform 9. Above is a double header formed of 41047 and 44569 en route to Worcester. Below, 43875 provides banking support to a passenger train heading west.

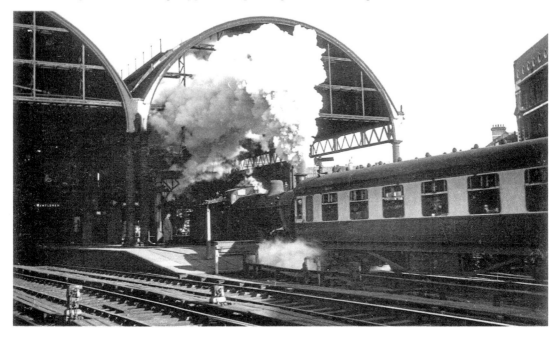

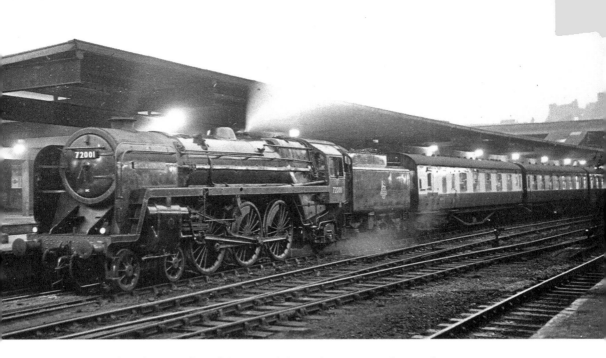

These pictures show how crude and functional the replacement roof was. *Clan Cameron*, 72001, was almost brand new when captured at platform 4 in January 1952. Below, the coach numbered M 9679 was used for training duties. What is of most interest is that platform 2 was still a bay, as it had been since 1854, exactly 100 years before the picture was taken.

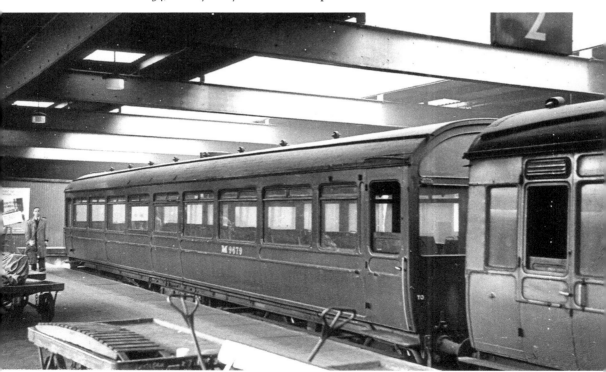

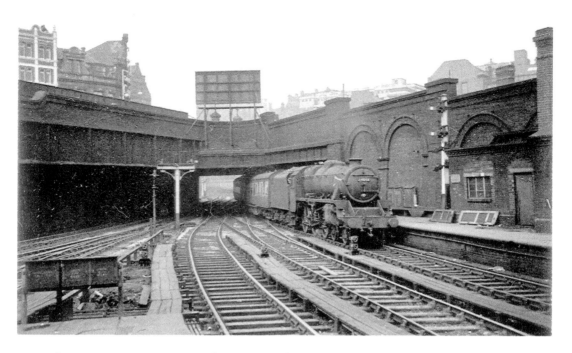

Above, 44843 is coming in to platform 7 on the southern half of the station. Behind the wall to the right was the now renamed Queen's Drive, formerly Great Queen Street. Behind the wall to the left lay Hill Street.

Below, 73031 sits close to the centre of platform 7, waiting for duty. The ornate roof and footbridge enhance the scene nicely.

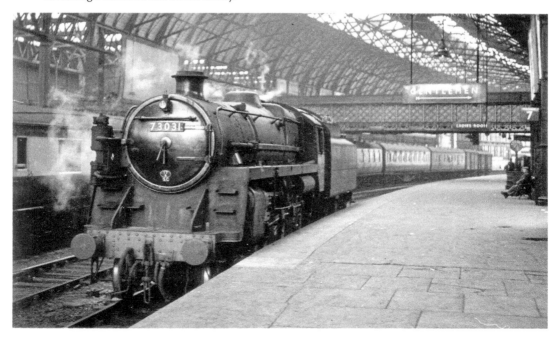

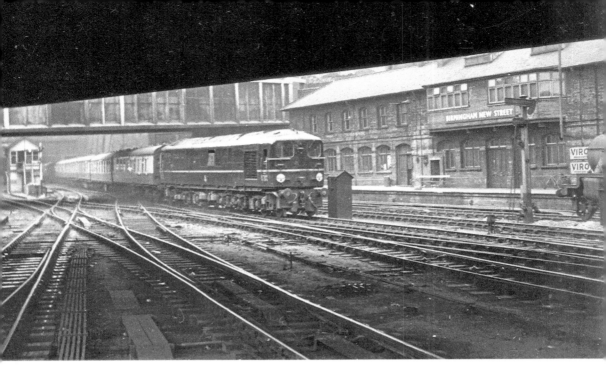

Early Diesels

Although steam would continue in operation until the mid-1960s, British Railways were keen to experiment with diesel-electric locomotives. 10202 was designed by Oliver Bulleid for the Southern Railway and completed in 1951. It was transferred to the London Midland region in 1955, hence these two pictures taken on 27 June 1955. They show the locomotive at both ends of platform 3. 10202 would be scrapped in 1963.

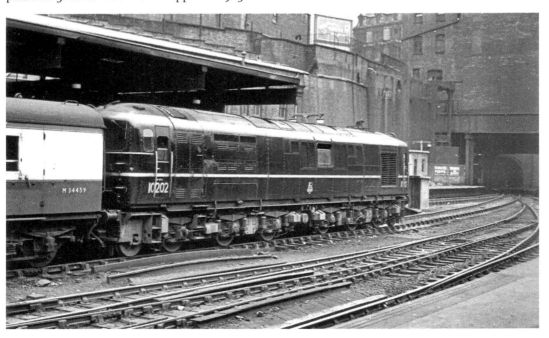

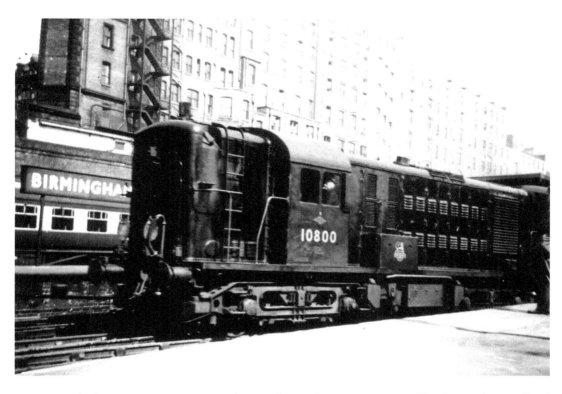

10800 had an even more interesting history, having been commissioned by the London, Midland & Scottish Railway way back in 1945. Production didn't take place until 1948–50. It wasn't a great success and was withdrawn from service in 1959. However, it appears to have been of interest to those lucky enough to see it pass through New Street, as these pictures from 1955 show.

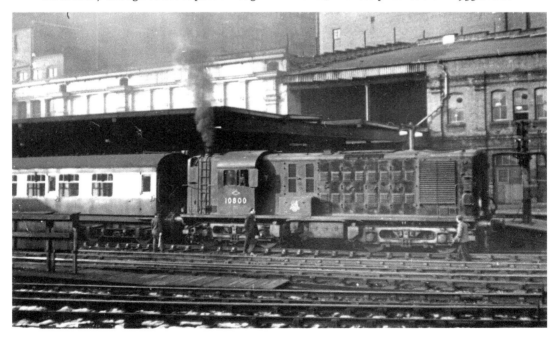

BRITISH RAILWAYS
(London Midland Region)

Details of Exhibits
NEW STREET STATION
CENTENARY CELEBRATIONS
1st—3rd June 1954

MIDLAND RAILWAY COACH

This non-corridor third class coach was built in 1910. It is 50 ft. long with eight compartments each having seating accommodation for twelve passengers. It is still in use for suburban traffic. The vehicle, although now fitted with electric lighting, was originally built with gas lighting.

L.N.W.R. COACH

Built in 1908 this corridor third class vehicle is 57 ft. long with eight compartments each having seating accommodation for six passengers and with lavatory compartment at each end. Although now fitted with electric lighting it was originally built with gas lighting.

QUEEN VICTORIA'S SALOON

This saloon, in which Queen Victoria made numerous journeys, was originally built in 1869 as two 30 ft. long vehicles gangwayed together. In 1895 the vehicles returned to their birthplace, the Wolverton Works of the L.N.W.R., and emerged as one coach, 60 ft. long and mounted on six-wheeled bogies.

Both oil and electric lighting were installed—by Royal Command—for although the Queen showed a most progressive outlook by insisting on travelling on the "new-fangled" iron road as early as 1842, she nevertheless doubted the reliability of electric light. Interior furnishings are in the well upholstered style of the age. There are two main compartments for day and night use, the sleeping compartment being in the centre with a dressing room adjoining. Double floors, filled with cork and deeply carpeted, ensured quiet travel.

QUEEN ADELAIDE'S SALOON

Showing in its design more than a trace of the horse and carriage days, this early Royal Saloon was built by the London & Birmingham Railway for the Dowager Queen Adelaide in 1842. It is a perfect specimen of the original bed-carriage design—the two seats of one compartment could be joined by a centre cushion to make a bed. Whilst the carriage exemplifies the best in railway coachbuilding of the 1840's, it demonstrates too, a lack of realization of what could be done to make railway travel spacious and comfortable. The frame is wider than the body, thus enabling attendants to move between the three compartments on the outside footboards. Lighting is by oil lamps, which were inserted through the roof. The body was built by a London coachbuilder and the 17-ft. underframe in the L. & B.R. workshops at Euston. Queen Adelaide, consort of William IV, was the first British Queen to travel by rail. Her carriage, which is preserved at Derby Works, is the oldest vehicle in the possession of the railways.

KIRTLEY LOCOMOTIVE No. 20002

Locomotive 20002 was built at the Derby Works of the former Midland Railway in 1866 to the famous double-frame design of Matthew Kirtley. It was withdrawn from traffic in 1947 after covering 1,660,000 miles during its working life of 81 years. It is now normally preserved at Derby Works. Matthew Kirtley, who is reputed to have driven the first train into London when part of the London & Birmingham Railway was opened in 1837, was an associate of George and Robert Stephenson and was the Midland Railway's first Locomotive Engineer.

Centenary Year

In June 1954, British Railways celebrated the centenary of New Street Station. Several exhibits were on display, as detailed in the brochure seen above and opposite. Kirtley Locomotive No. 20002 was originally numbered 158A and is seen below in fully restored condition. It was built in 1866 and continued in service until 1947. Today, it is on display at the Matthew Kirtley Museum in Derbyshire.

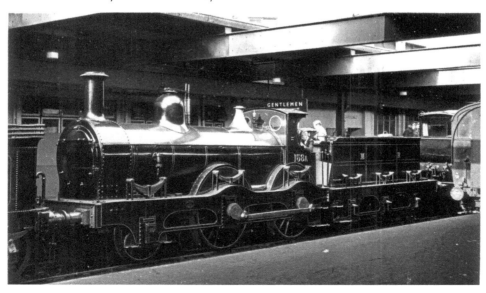

Kirtley Locomotive No. 20002—(*continued*)

Kirtley's personality as a fireman and driver was reflected in his 2-4-0 design, of which No. 20002 is the sole surviving example. Robust and simple, these locomotives were easy to maintain and had long lives. As originally built No. 20002 weighed 62 tons 5 cwts. in working order.

LOCOMOTIVE "HARDWICKE"

One of the immortals of the 7,000 odd engines built at Crewe is the L.N.W.R. Precedent class 2-4-0 express passenger locomotive "Hardwicke". Built in 1892 to the design of F. W. Webb, this engine won fame in the "Race to Scotland" on the 22nd August 1895. Heading an express it covered the 141 miles between Crewe and Carlisle in 126 minutes—an average of 67.2 m.p.h. This remained a record for more than 41 years and was lowered by only four minutes. "Hardwicke" ran for more than 1,326,470 miles before she was "retired". She is normally kept at Crewe Works and is still in working order.

LOCOMOTIVE "CITY OF BIRMINGHAM"

The "City of Birmingham", No. 46235, a Stanier-designed 4-6-2 express passenger locomotive, was named at New Street Station nine years ago. The unveiling of the nameplate and the coat of arms of the city on the side of the locomotive was performed by Alderman W. H. Wiggins-Davies, the then Lord Mayor of Birmingham, who rode on the footplate from one end of the station to the other.

The "City of Birmingham", like some other locomotives of the ex L.M.S. "Coronation" class, was originally streamlined. The casing was removed in 1946. With a power rating of 8P they were designed for through working on the fastest and heaviest express passenger trains between London and Scotland. The tender carries 10 tons of coal and 4,000 gallons of water. The weight of engine and tender in working order is 161 tons 12 cwts.

Exhibition at
NEW STREET STATION
1st—3rd June 1954
in connection with
the
CENTENARY
CELEBRATIONS

DETAILS OF
EXHIBITS

On the evening of 1 and 2 June 1954, the Stephenson Locomotive Society ran special trains for enthusiasts. Part of the journey involved a trip along the old Halesowen Railway line from Old Hill to Longbridge. Below, the driver of 58903 is exchanging the special token required to work the single line track with the signalman from Halesowen Junction box.

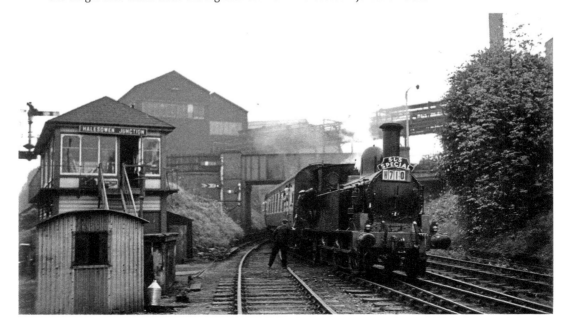

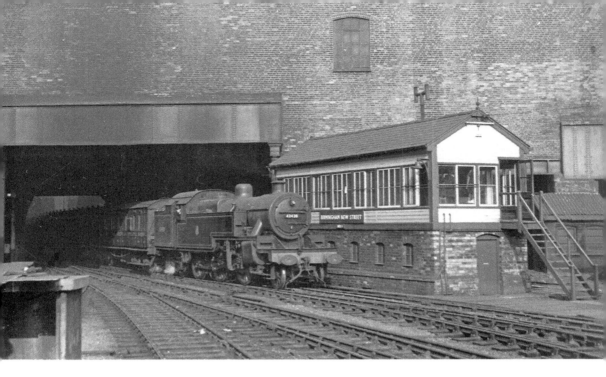

Signal Boxes

Signal Box No. 1 lay at the far eastern end of the station, close to the end of platforms 3 and 4. In 1954, it was manned by two signalmen and featured sixty-three levers.

The view above shows 42420 passing the box as seen from the end of platform 1. Below we see that this part of the station was very popular with train spotters.

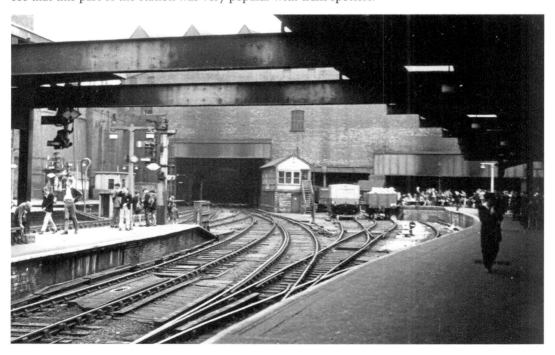

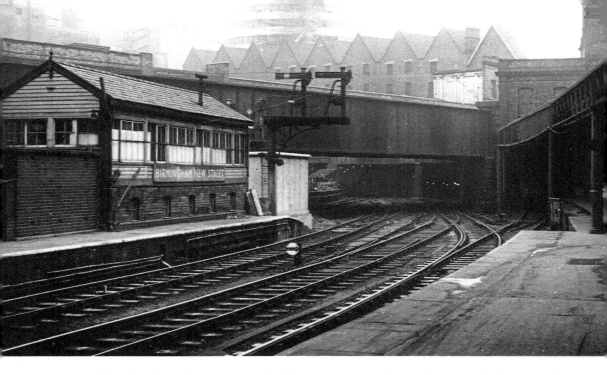

No. 2 box also lay at the eastern end of the station. It was located between platform 8 and 9. Above is the box as viewed from platform 10 in April 1964, hence the appearance of the Rotunda in the misty distance. Below is the interior of the box, which was operated by one signalman and had seventy-five levers. This 20 March 1954 scene captures Walter Pritchard, to the left, and his colleague, Mr Bing, about to swap shifts.

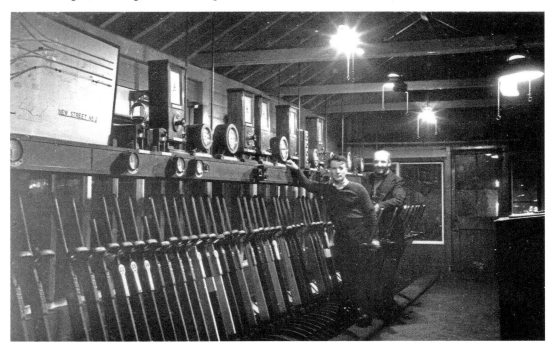

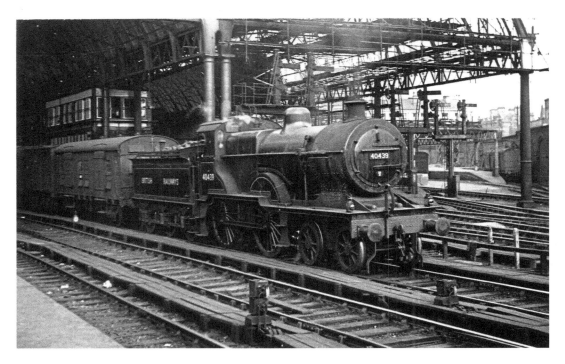

Signal Box No.4 was at the western end of platform 8 and 9. It can be seen to the left of the picture above, behind the goods train being pulled by 40439. For those wondering about No. 3 Box, this was the one that was taken out of service in 1946, as described on page 17. No. 4 box was operated by one signalman and contained seventy-three levers.

No. 6 box was located at the western end of platform 2, underneath Navigation Street. It was a one-man box containing eighteen levers.

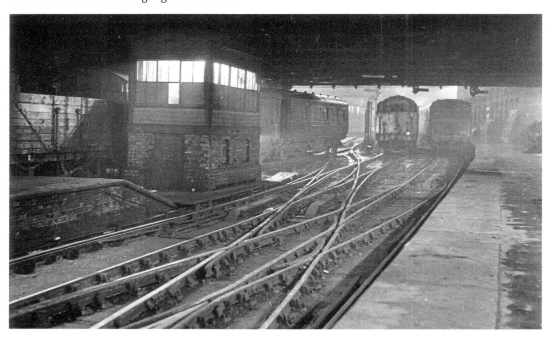

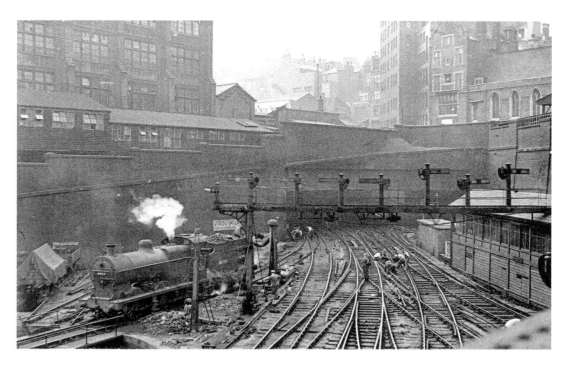

No. 5 box was the biggest and was located at the far western end of the station. The 153 levers needed three signalmen to operate them. It was partly demolished by a bombing raid in October 1940.

Above, the box is seen to the right. The picture, taken by peering over the wall at the junction of Navigation Street and Hill Street, also shows work on the track and part of the turntable that existed in this part of the station. The other view shows the box looking neater thanks to a coat of paint. Again, the turntable is visible to the left.

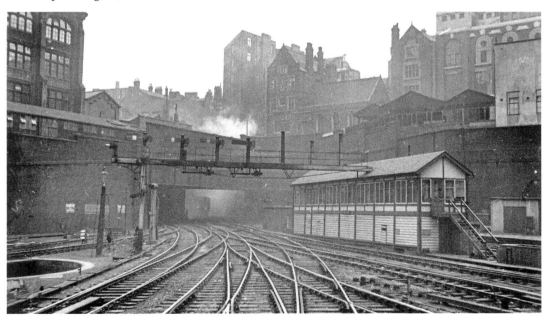

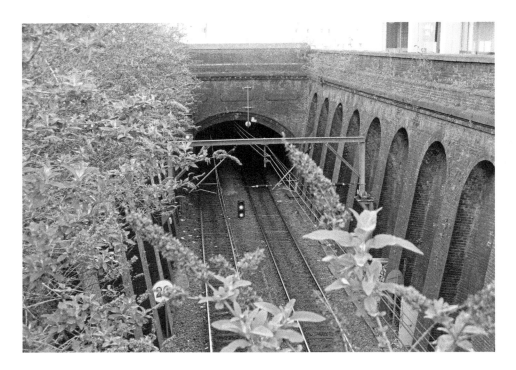

Tunnels

Given its location in a kind of natural amphitheatre, every approach to the station is via a tunnel. With electrification starting in the early 1960s, this caused some major problems. Above, this brief opening off Holliday Street will be familiar to many a Cross-City line traveller. Luckily, tunnel height here allowed for the overhead wires to be installed.

Below are the tunnel entrances that lay between Worcester Street and High Street. With only just enough room for steam locomotives, some major work would be needed.

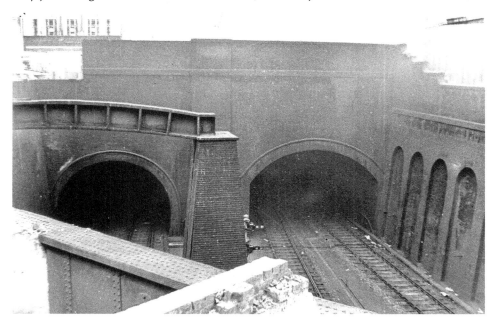

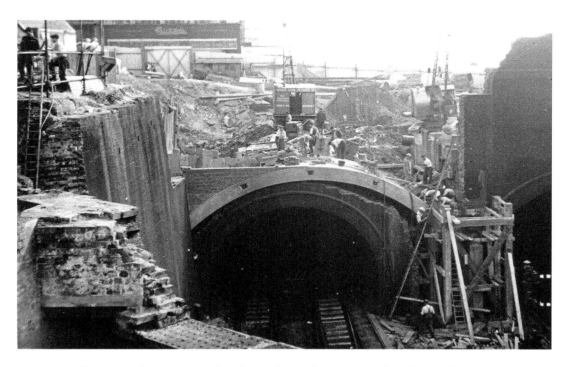

It would prove to be a major undertaking. Above, the new tunnel roof is clearly visible above the old. Below is a busy scene at the other tunnel entrance. Today, these tunnels are located close to the base of the Rotunda and are no longer visible, having been extended later in the 1960s.

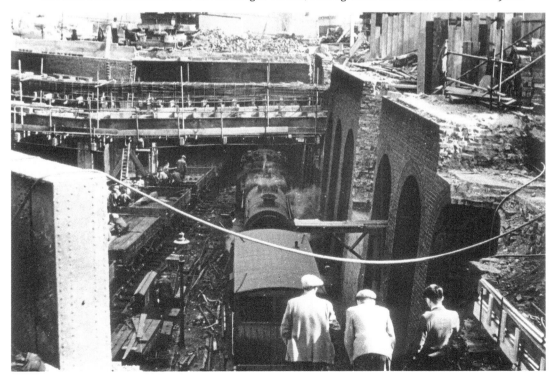

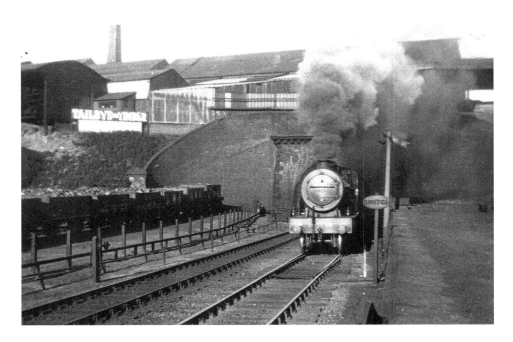

Anyone who travels from New Street to Wolverhampton will be familiar with a long period underground before the daylight returns. The north tunnel passes under Broad Street and Centenary Square. Prior to the construction of the National Indoor Arena, the exit from this tunnel used to be to the north of the canal near the Malt House public house, as seen above. Now passengers must continue in the dark to St Vincent Street, exiting from underneath the NIA West car park.

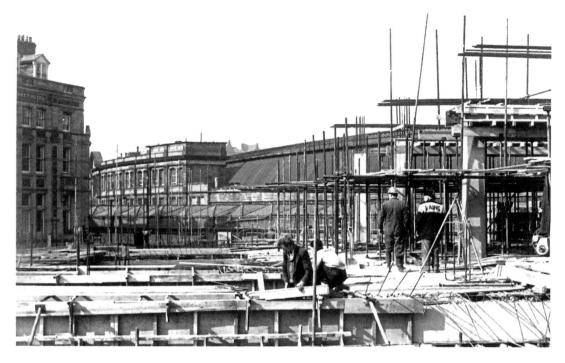

The Final Years

Construction of Birmingham's Bullring Centre started before work on the station. Above is a *c.* 1962 view from the old Worcester Street looking towards Station Street. The workmen are constructing the building that will house the Midland Red bus station. Below, the March 1962 view is down Station Street towards the construction site.

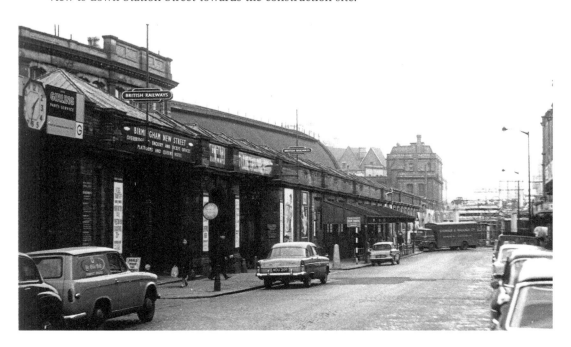

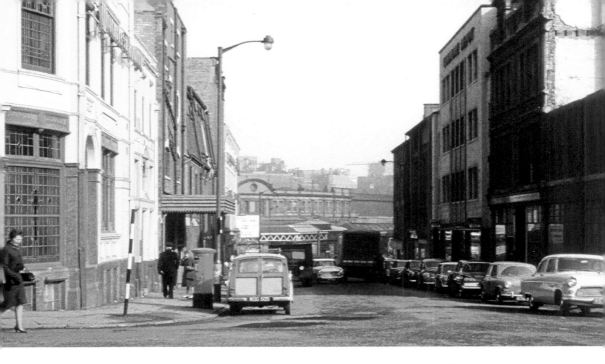

These 1963 colour pictures capture the old southern side of the station, nestling down in the city centre much as it had done for almost 80 years. Above is the view from the junction of Station Street and John Bright Street. To the left is the Queen Victoria public house. Below, the view is from close to the junction of Hill Street and John Bright Street.

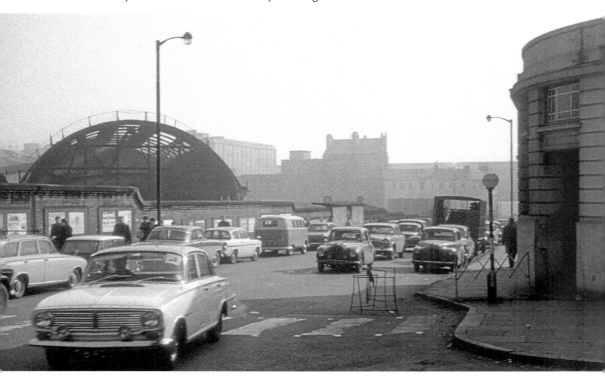

Another *c.* 1963 picture from the junction of Navigation Street and Hill Street. While the modern Rotunda takes shape in the distance, the ancient pillars marking the entrance to Queen's Drive are unchanged from the picture seen on page 13.

By peeking over the wall on Hill Street, the site of the old turntable could be viewed and is especially clear in the snow that fell in February 1963.

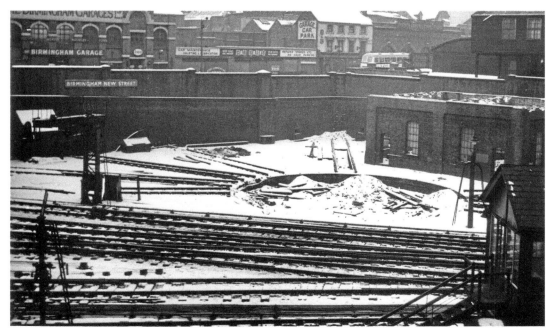

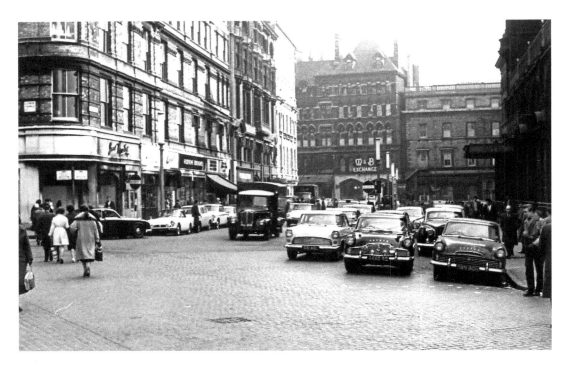

Two complementary views of the site of the Queen's Hotel, both *c.* 1963. Above, the view is along Stephenson Street towards Stephenson Place with the Queen's Hotel on the far right. Below, the view is looking down Stephenson Place towards Stephenson Street and the hotel and station entrance can be seen clearly. On the right is the Midland Bank, now Waterstones book shop.

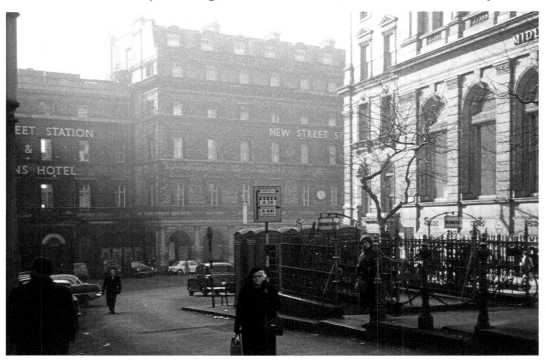

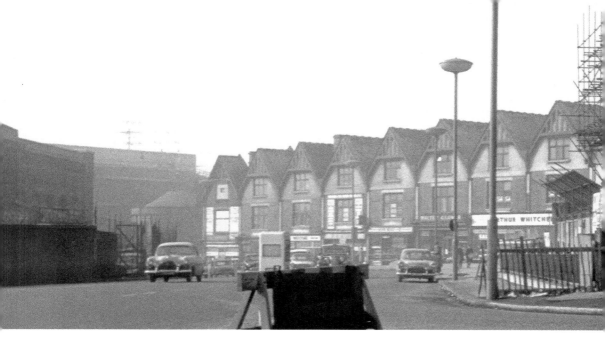

Again, two complementary pictures, this time showing the eastern entrance to Queen's Drive off Worcester Street. The gable ended shops were on a curiously shaped plot which meant the ones closest to New Street were much bigger than those at the Queen's Drive end of the block.

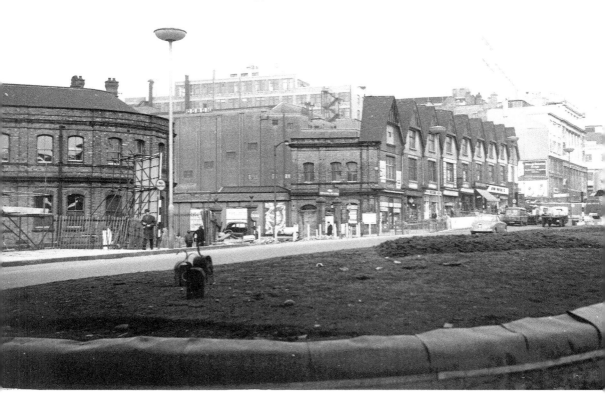

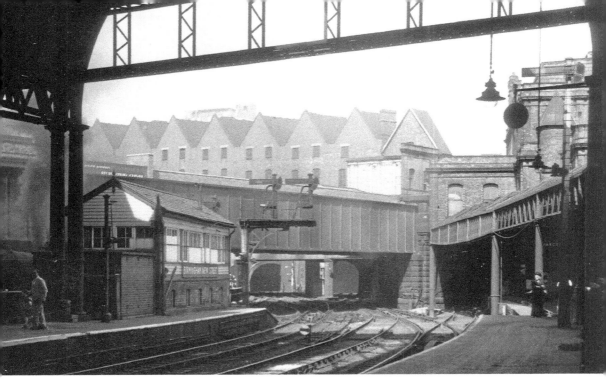

Above, a nice view of the rear of the gable ended shops with Queen's Drive passing from left to right across the centre of the picture. Below, a Scammell Scarab is sat outside the now rather sad looking L&NWR Parcels Office at the eastern end of Queen's Drive.

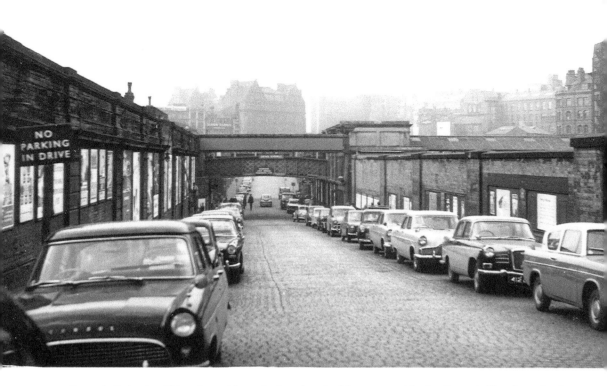

Queen's Drive in all its glory. Above is the view looking west with the Queen's Hotel on the far right. Below is an easterly view with the spire of St Martin's church in the misty distance. In both, the footbridge across the station appears in the centre.

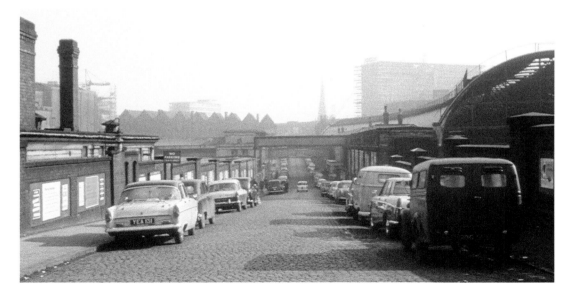

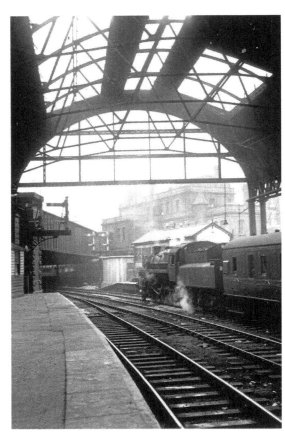

The eastern end of the southern side of the station. Left, the view is from platform 7 with Queen's Drive to the left and box No. 2 and the old Midland Railways Parcel Office in the centre. Below, the view is reversed with Queen's Drive on the right.

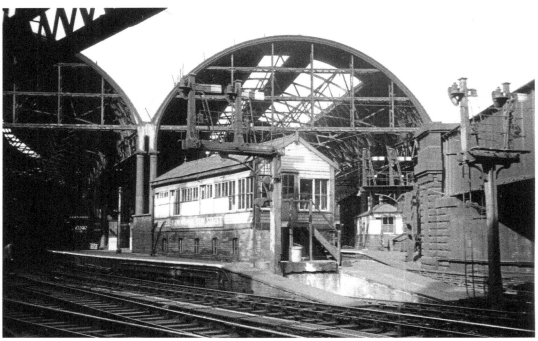

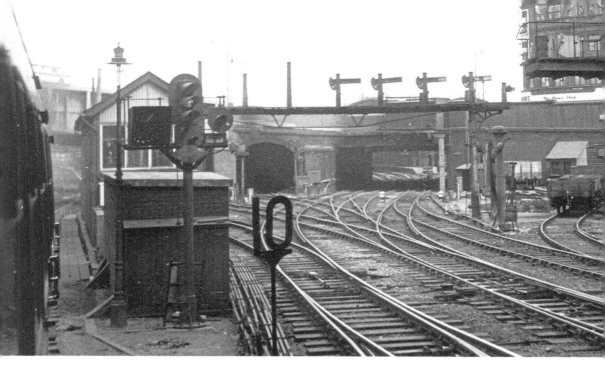

The western end of the station is captured in these scenes. As a train passes box No. 5, the heavily curving tracks leading to the southern side of the station can be seen heading underneath Navigation Street and Hill Street. Below, platforms 1 to 6 are all visible. In other words, the whole of the original station. Hill Street passes overhead.

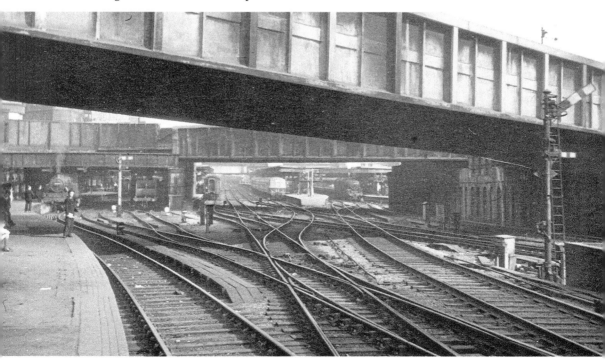

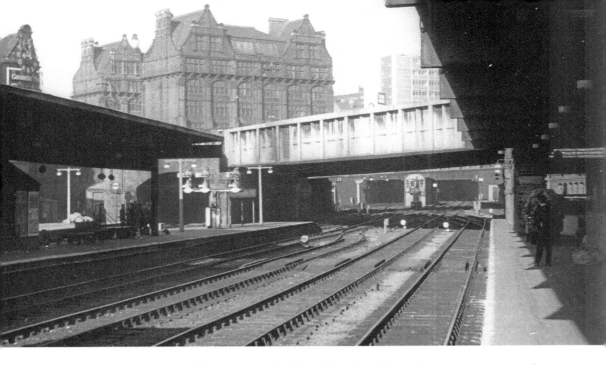

Two particularly quiet views of the western end of the old station. Above, the scene was captured from platform 3. The bridge is carrying Navigation Street while the building dominating the background is the home of Matthew Boulton College, formerly the Central Technical College and Birmingham Central Grammar School. The other view is from platform 10 and shows box No. 5 under the bridge.

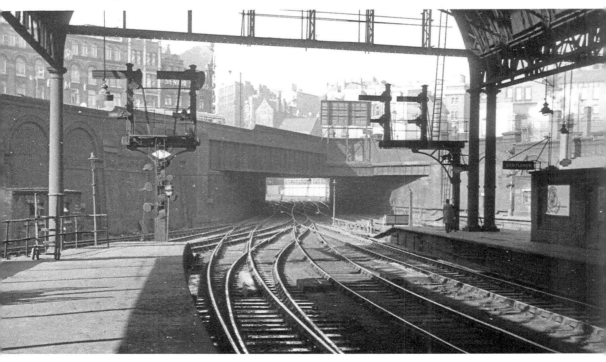

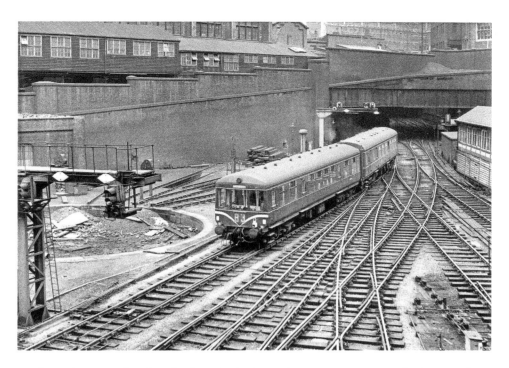

By the early 1960s, diesel multiple units (or DMUs) were in operation. The journey from New Street to Redditch often used such trains. Above, an empty train passes the site of the now disused turntable, filled with rubble. Below, a Redditch bound train departs from platform 11.

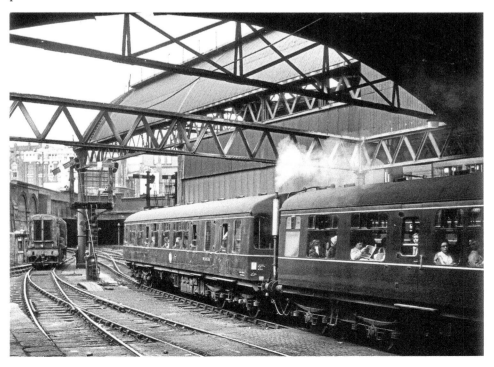

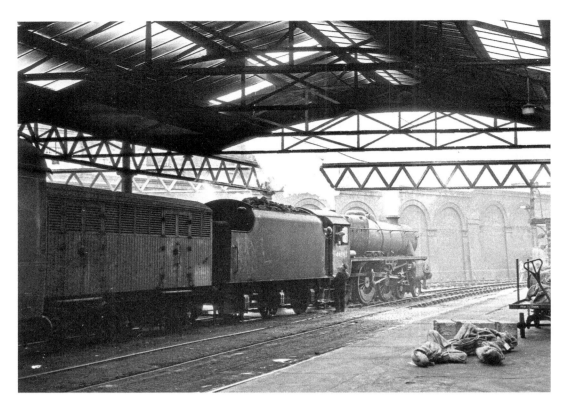

At the very southern side of the station lay the fish sidings. It was here that fresh fish was unloaded and taken to nearby markets. The area was well known for the aroma, especially in the summer. Above, 44943 is pulling a well ventilated wagon, presumably used for the transportation of fish. The other view shows the siding standing empty as it approaches the end of its useful life.

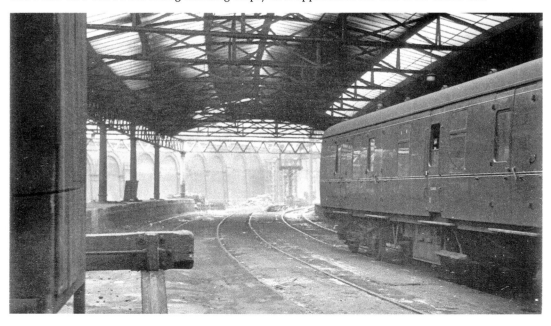

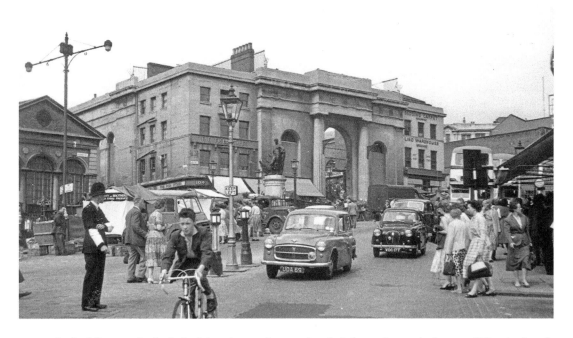

The building on the far left of the picture above, taken in July 1958, was the home of Birmingham's Fish Market. Fish unloaded from New Street had a short journey along Station Street and Bell Street before it reached the market on Spiceal Street. On the opposite side of Bell Street was the Fish Stores. No doubt their fish was as fresh as possible, despite being located almost in the centre of the country.

The aerial view from *c.* 1960 shows both the old station and the old Market Hall but the Fish Market had already been demolished as work on the Inner Ring Road project moved on apace.

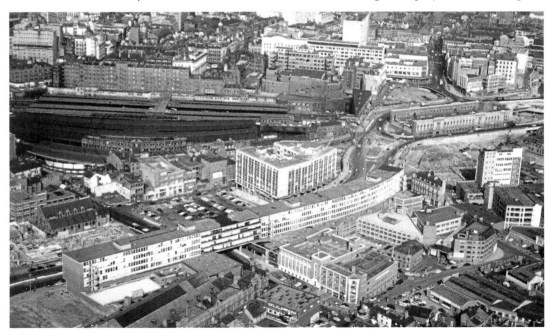

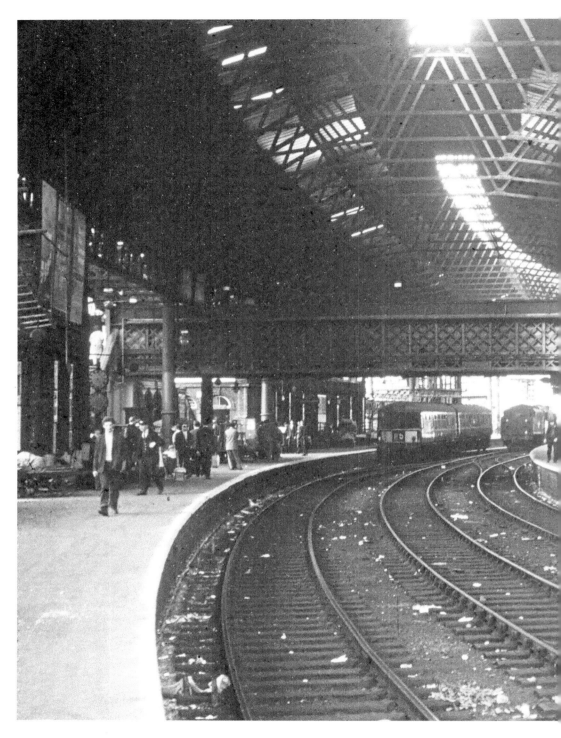

Although taken in August 1964, after work on the station had commenced, this scene showing platform 8 and 7 on the old Midland side of the station shows how little had changed since it had opened in 1885 (compare with the picture on page 9). Only the years

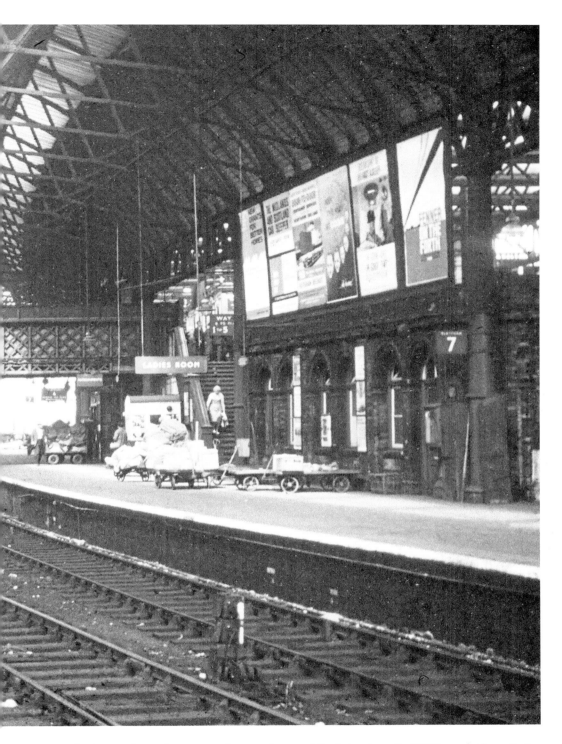

of grime and soot from steam locomotives and the intrusion of a DMU on platform 8 give the game away. But this really was the end, as we will see on the following pages.

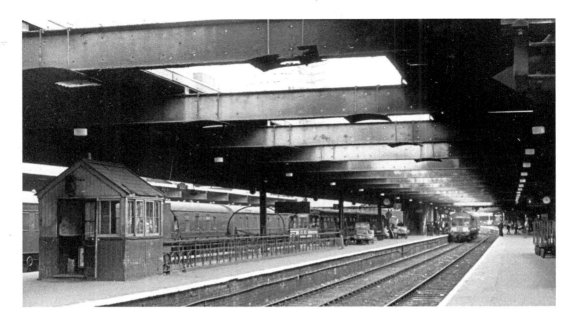

1960s Rebuild

The 1960s was a time of major change for the city of Birmingham and New Street Station would feel the full effect of this. Above, the northern side is not yet seeing this, although the Rotunda nears completion nearby. The railings mark the site of subways that connected the platforms. These were for goods only, not passengers.

By mid-1964, the southern half of the station was undergoing major work. 42707 eases past the workmen while onlookers peer over temporary barriers on Hill Street. The building under construction is now the Gala Casino, then the Savoy.

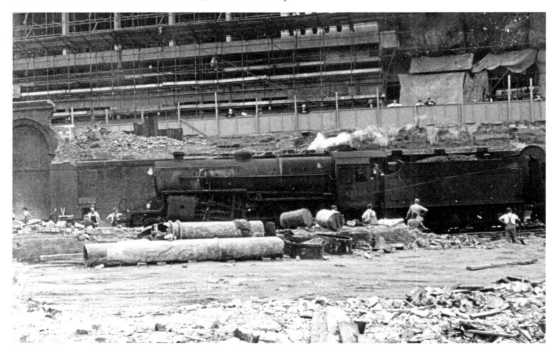

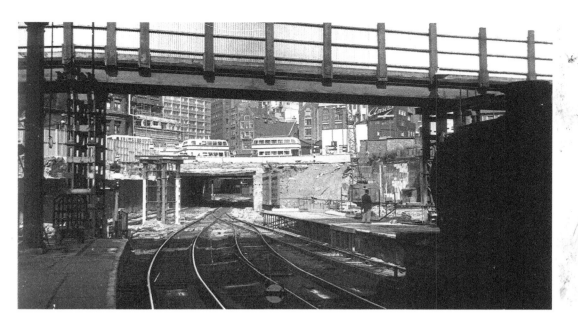

Although taken from platform 8 instead of 10, the view above should be compared with that at the bottom of page 44 to appreciate the scale of the changes taking place. The Hill Street entrance to Queen's Drive is no more, replaced by a pile of rubble. In the distance, the new signal box takes shape and will replace the five old signal boxes.

Looking from Navigation Street, the northern side of the station continues to operate much as it had for 110 years. But the pile of rubble in Queen's Drive indicates that this will soon change.

The ugly steel structure seen in both pictures ensured the ancient right of way remained in place while work continued.

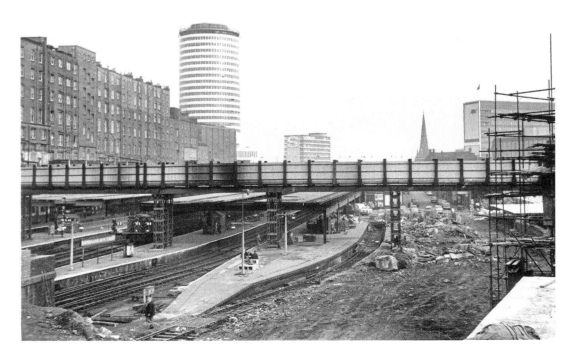

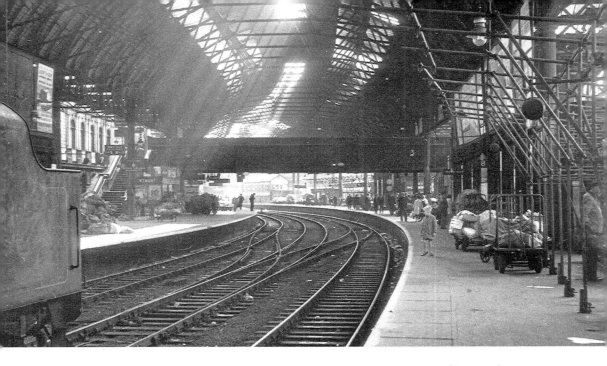

Just three months separate these views from platform 8. On 1 August 1964, the easterly view shows sunlight streaming through the almost 80 year old roof. The westerly view, from 31 October, shows the roof has been removed, most likely sent for scrap. 45369 sits on the central road between platform 7 and 8 with the old British Railways emblem on its tender.

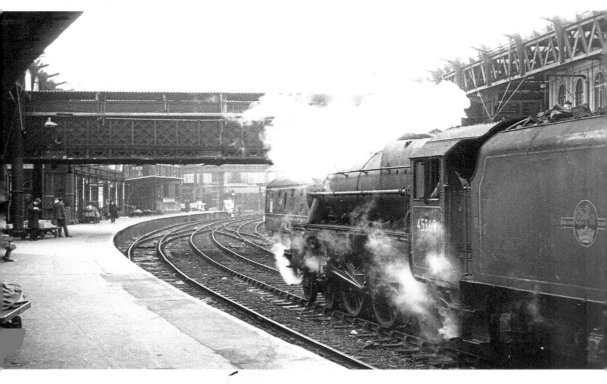

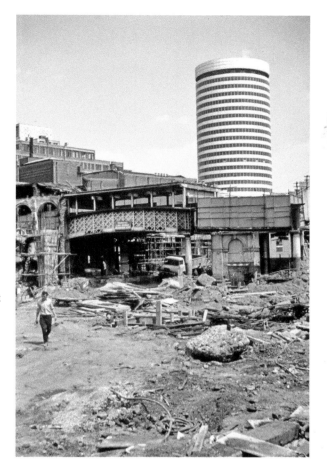

One of three superb colour pictures by Richard Law (snr), the scene right demonstrates a city undergoing seismic changes. The shiny modernity of the Rotunda could not provide a greater contrast to the old bridge across Queen's Drive.

Below, the new platform 10 is already complete and operational, as is the Bullring Shopping Centre whose familiar bull emblem can be seen adorning one of the new buildings on the city's skyline.

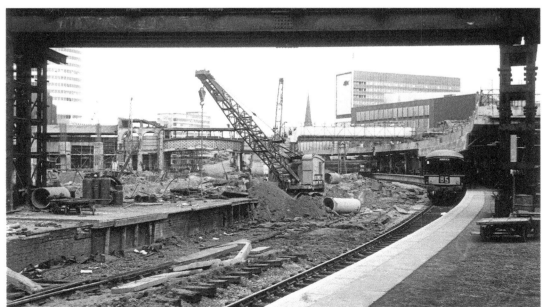

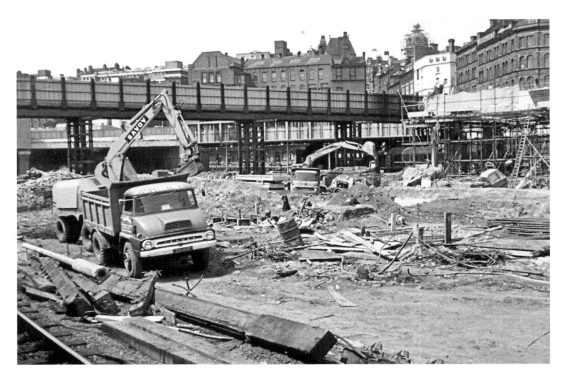

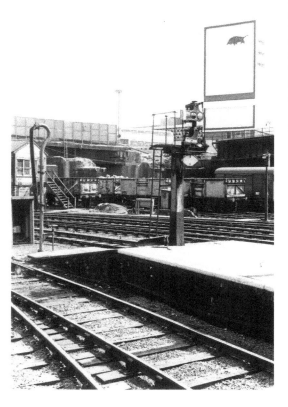

Above, more evidence of the massive scale of construction during 1964. Left, the scene is more restrained, but look closely and it's clear that the eastern end of Queen's Drive is being worked on. Also, the old gabled ended shops in Worcester Street, as seen on page 39, have been demolished.

Again, the new Bullring makes its mark on the skyline.

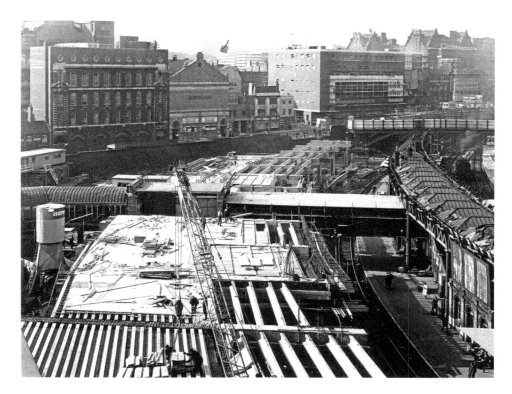

These complementary views across the station, both taken from Worcester Street, provide a complete record of the scene as development continued. Above is the southern half of the station with work well underway on the concrete that will eventually bury the new platforms. Below, the northern half still remains relatively unscathed. The old slate roof of signal box No. 1 makes its presence felt amid the concrete and steel while the new signal box appears to be complete, if not operational.

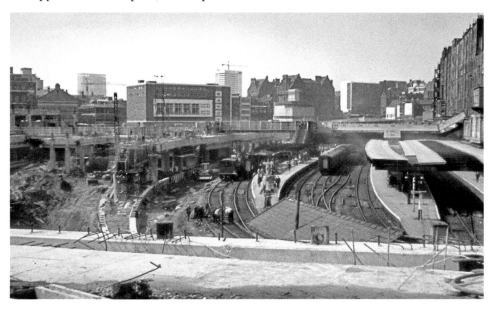

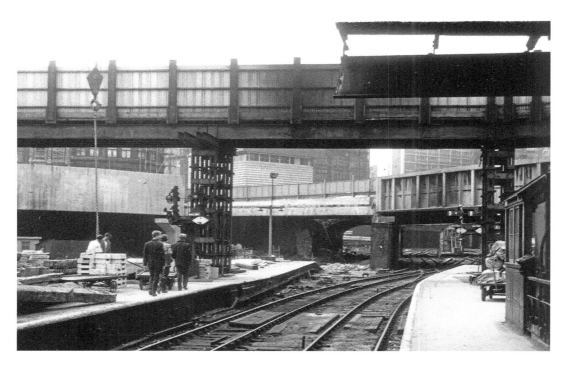

Moving forward to May 1965, it is clear that there is still much work to be done. The complete reconstruction of a station covering 12 acres of land is not something that can be rushed, especially when trains still need to use it.

However, the new platforms 11 and 12 are now open but are blighted by the darkness that will plague the whole station in the years to come. The main benefit of the rebuilding was an increase in the number of through platforms to twelve.

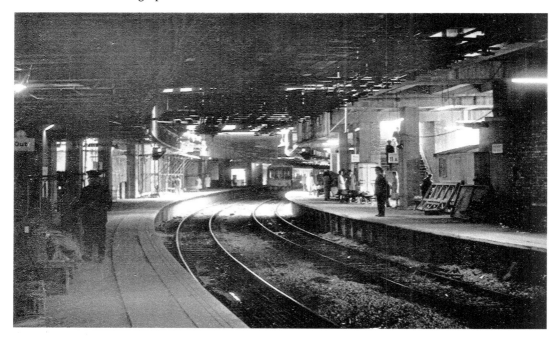

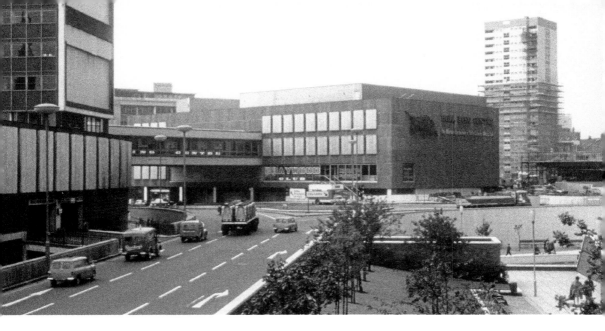

Outside the station, the Bullring and Inner Ring Road were now accepted features of the city. Manzoni Gardens, named after city engineer Sir Herbert Manzoni, had replaced the old Market Hall, originally opened in 1835.

As part of the station development, Stephenson Tower was constructed in an effort restore city living, something lost as part of the slum clearances that were still ongoing. It was, perhaps, ahead of its time as city living in Birmingham only really started to pick up in the late 1990s.

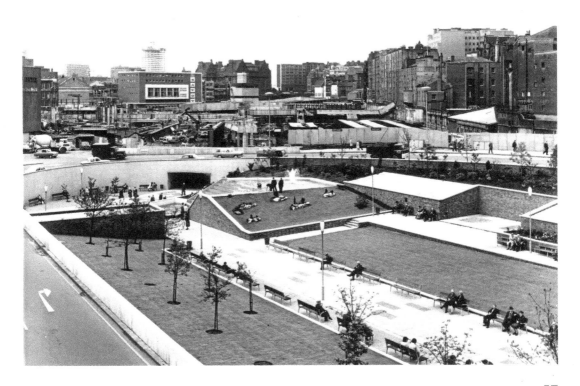

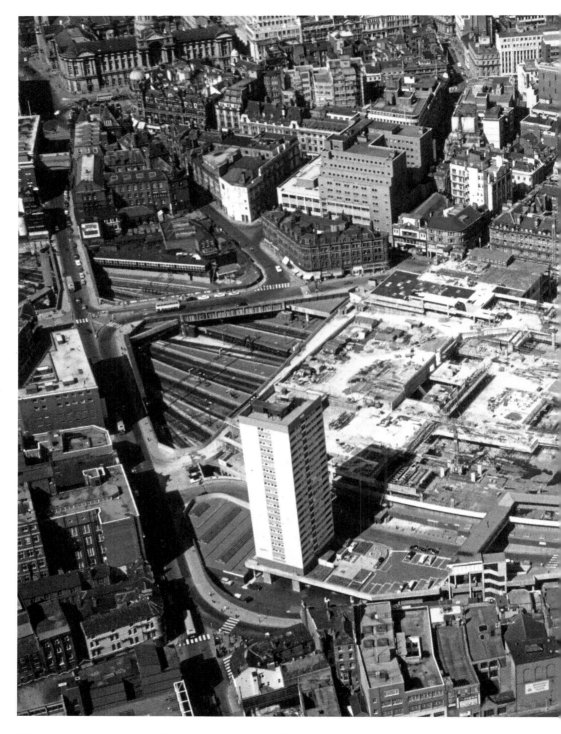

The station was completed in 1967 but that wasn't the end of development on the site. British Rail sold the 'air rights' above the station, which resulted in it officially being reclassified as an underground station. Above, the Birmingham Shopping Centre is being constructed, a project

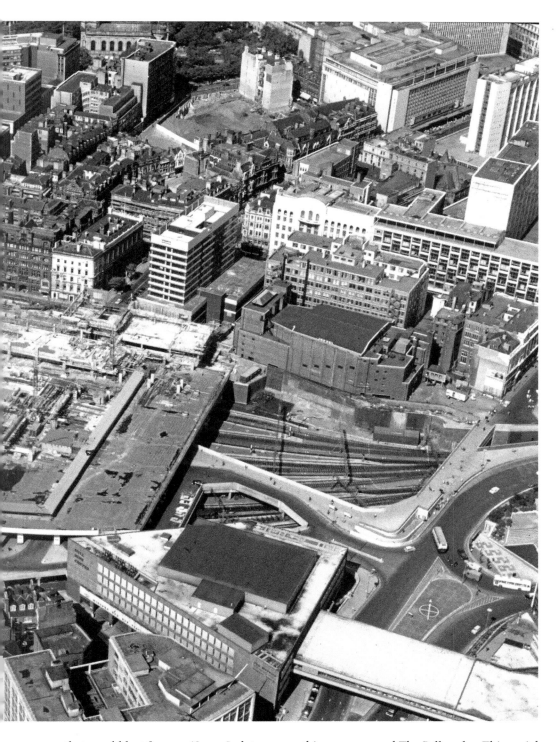

that would last from 1968–70. In later years, this was renamed The Pallasades. This aerial view really gives a feel for the scale of New Street Station as part of the city.

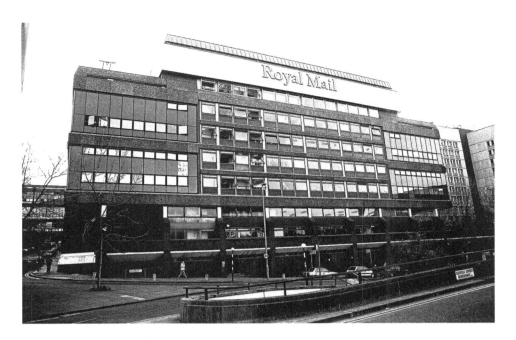

Mail Connections

The old station had featured a subway from platform 1 to the post office at the top of Hill Street. When Royal Mail wanted to construct a new, mechanised sorting office on Severn Street, parliamentary approval was sought for new tunnels under the city. When it opened in 1970, the new sorting office was the largest in the county. Today, the building is more familiar as The Mailbox, having been converted in the late 1990s.

In June 2007, a tour through the tunnels took place and Michael Scott captured the atmospheric scene.

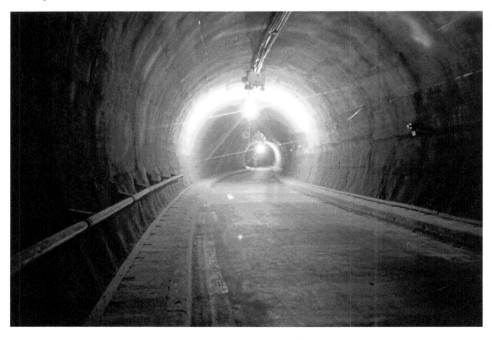

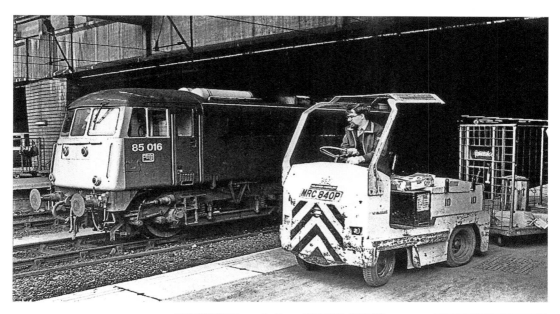

A regular sight in the 1970s New Street Station was the appearance of battery powered vehicles pulling trucks laden with parcels and sacks of mail. Subways on some of the platforms provided direct access to the nearby sorting office. Taking mail by train has since fallen out of fashion, with road transport now preferred.

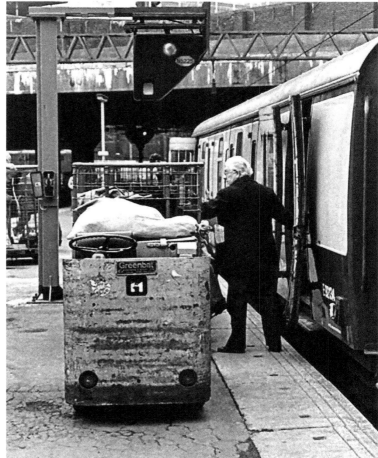

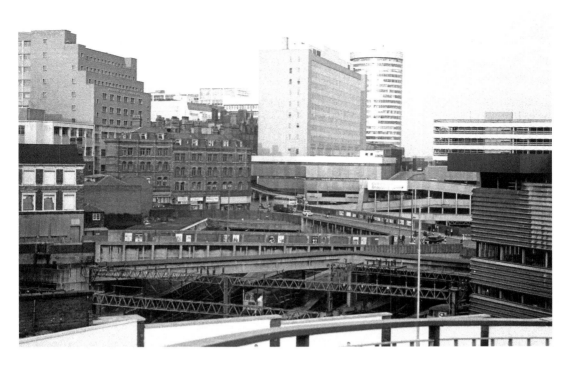

1970S

By 1973, the new station was already looking dirty and depressing. The concrete that had been gleaming and fresh less than ten years earlier was attracting dirt and grime from the trains and city centre traffic. These scenes show the western end of the station close to Navigation Street. The signal box looks especially unpleasant.

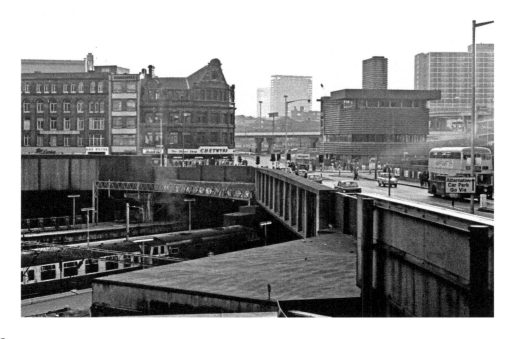

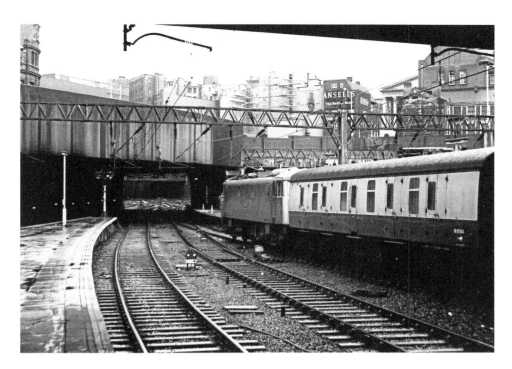

Inside the station, the huge concrete slab at the end of platform 10 did not create a good impression for visitors to the city. No wonder Birmingham developed such a poor reputation in the 1970s and 80s, thankfully very much improved in recent years.

However, a bit of sunshine always seems to bring out the best in concrete buildings and the June 1974 scene, below, shows the 1970s station in its most flattering light. The sight of InterCity trains and local services, all in standard British Rail livery, is very much different to the multi-coloured trains of today.

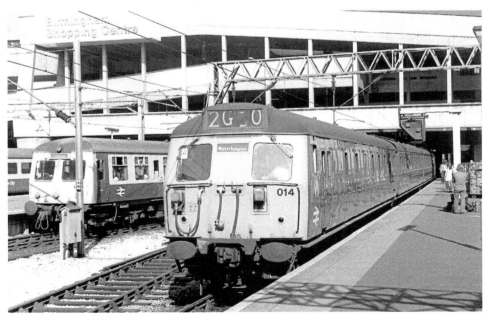

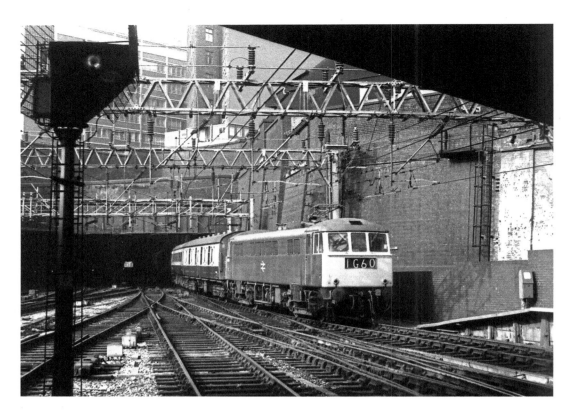

At the far western end of the station, where signal box No. 5 and the old turntable had once stood, modern electric trains now plied their trade. The Class 86 locomotives were actually built in the mid-1960s, especially for use on the West Coast Main Line that passes through New Street, so it's not surprising to see so many pictured in the mid-1970s.

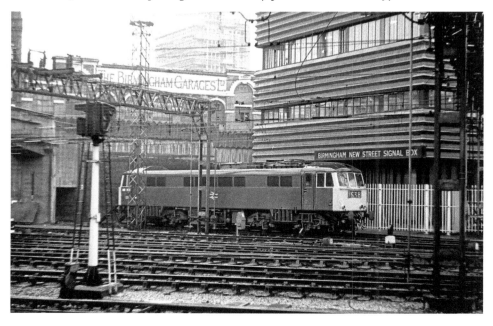

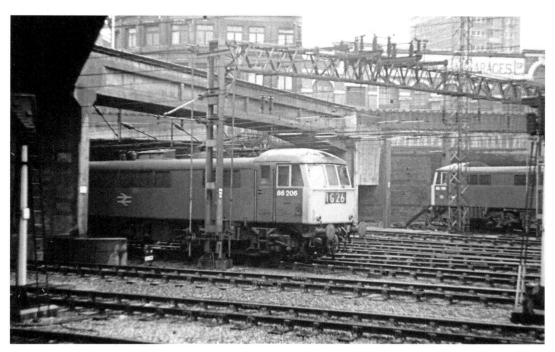

Class 87 locomotives were built in the early 1970s and became the flagship of the British Railways electric fleet. The one captured, right, is sat at the eastern end of the station, most likely on platform 4. In the background is a diesel shunter, another familiar sight in the 1970s station.

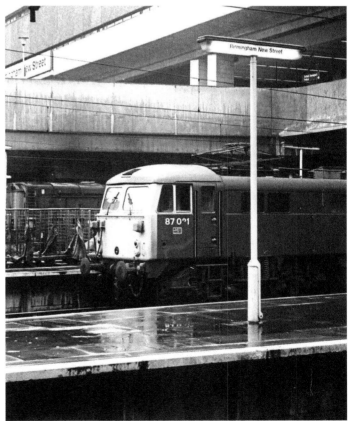

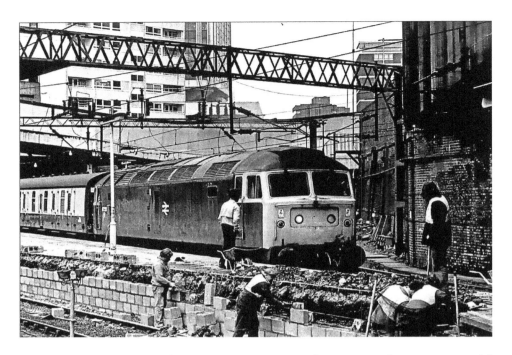

Diesel locomotives were also frequent visitors to the station. The very successful Class 47, above, saw 512 examples constructed between 1962 and 1968. They were commonly referred to as Brush locomotives as many were built at the Brush factory in Loughborough.

Below, a trio of Class 50 diesels sit at the eastern end of the station.

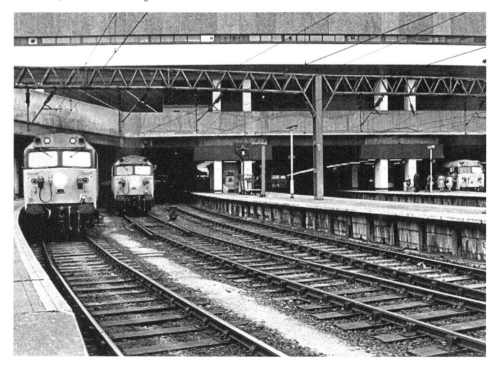

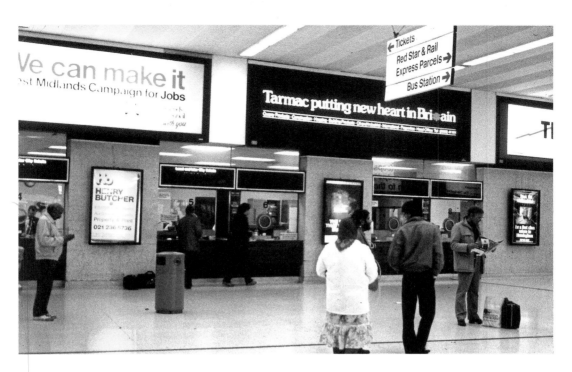

1980s

One major change introduced by the 1960s rebuild of the station was the introduction of a coherent entrance and concourse. These 19 July 1987 views show the ticket office, above, and main concourse, below.

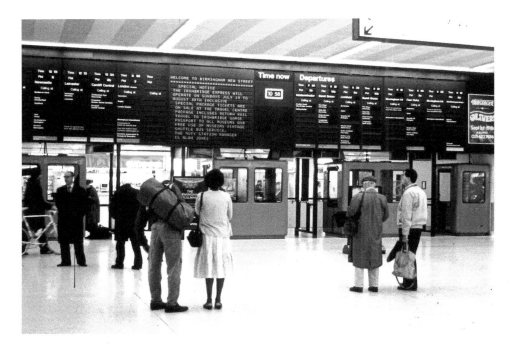

Another change introduced in the 1960s was that the station was no longer 'open', as described on page 7. Instead, a conventional ticket barrier sat between the concourse and the access to the platforms. This was possible as the ancient right of way was maintained via the shopping centre above the station with an entrance on Station Street and Stephenson Street.

Congestion caused by siting the departure board above the ticket barrier saw the former relocated in the concourse in later years.

Just through the ticket barrier was the Travellers Fare Quicksnack outlet. This was run by the catering arm of British Rail.

Access to the platforms was via a drab, fluorescent lit corridor. Back in the 1980s, litter bins were located at regular intervals along the corridor. The terrorist threat of modern times has seen such useful bins removed from many public places around the country.

Once the traveller had descended via the stairs (there were no escalators), the darkness only worsened. This no doubt contributed to the station becoming one of the most hated buildings in the country.

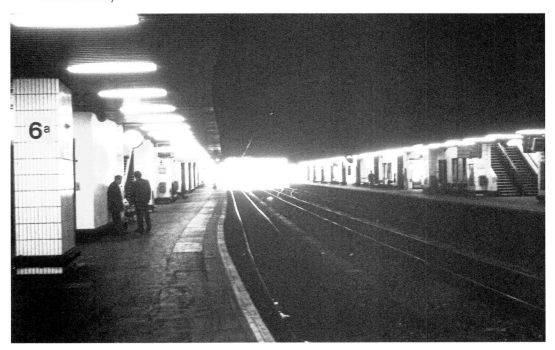

Signs of the Past

Both Queen's Drive and Worcester Street have been mentioned many times on the preceding pages. Both survived the 1960s reconstruction, but in heavily modified form.

The grand Queen's Drive was removed completely, but the new access road through the station, from Hill Street to St Martin's Circus Queensway, was given the name Queens Drive.

Worcester Street had once led all the way from Edgbaston Street. After the Inner Ring Road was built, all that remained was a small service road close to the Rotunda.

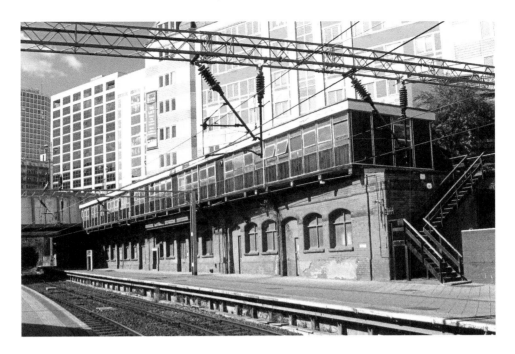

Lamp Block

Another survivor of the 1960s changes was an old building on platform 1. This had originally been the L&NWR lamp block. This became the first area to be developed in the current rebuilding of the station and staff offices for Cross Country trains were built in its place. In a nice nod to the past, staff refer to this new building as the 'lamp block' so the name continues even if the structure has been lost.

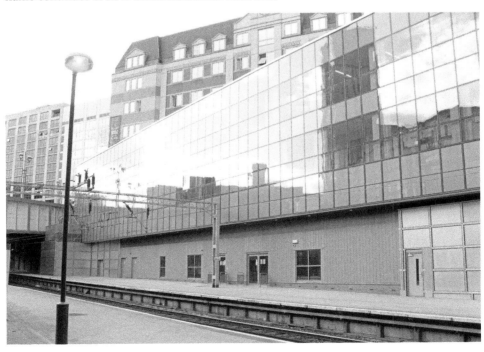

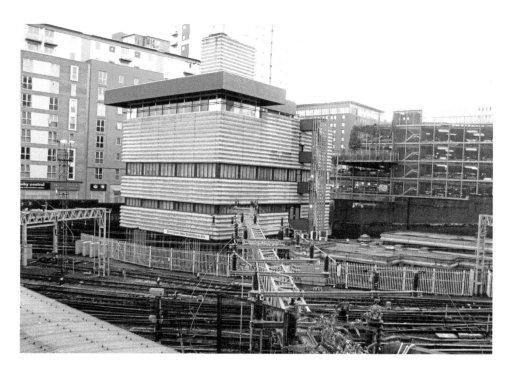

The 2000s

Above, the signal box at New Street Station as seen from Hill Street. Designed by architects Bicknell & Hamilton in collaboration with R. L. Moorcraft, the Regional Architect, London Midland Region, this example of Brutalism was granted Grade II listed status in 1995.

Below is the junction of Navigation Street and Hill Street, where the entrance to Queen's Drive used to be located. The less than attractive car park to the right of the Rotunda sits on top of the Pallasades shopping centre.

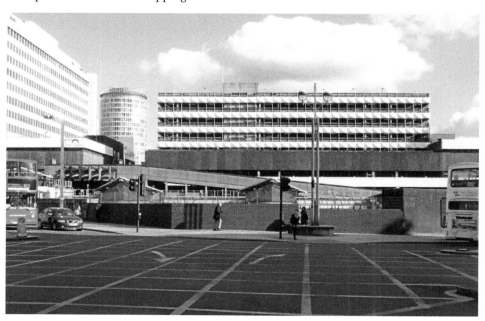

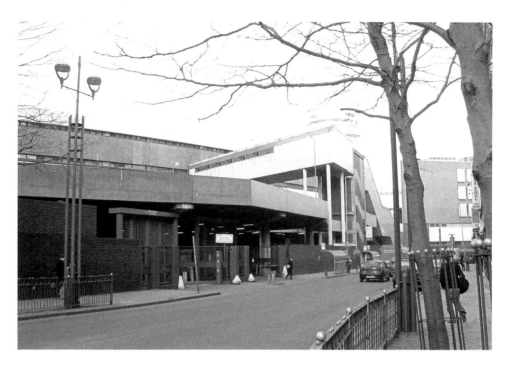

Station Street as it was in March 2006. The entrance to the Service Centre was via the blue gates. Here, deliveries of food and drink for trains were made. Further down the street was the access to the right of way through the Pallasades, by this time a smelly and deeply unpleasant set of concrete steps that most people went out of their way to avoid.

Below is the eastern end of the station, pictured in April 2006.

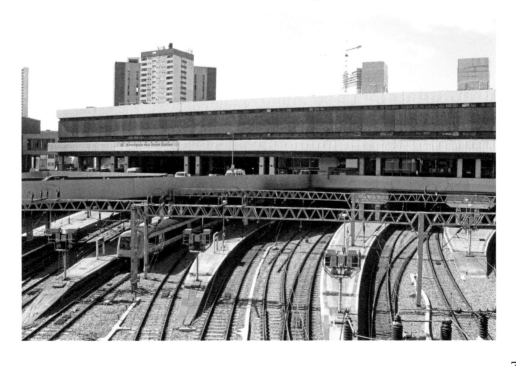

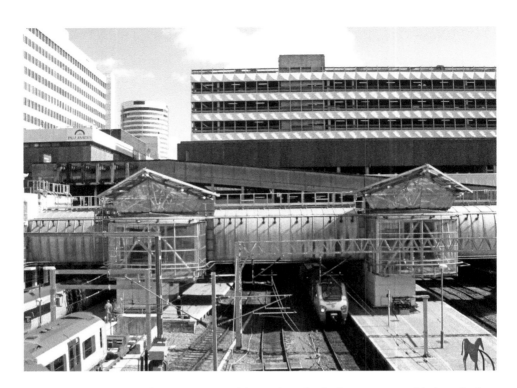

At the western end of the station, an additional method of access was added in the late 1980s. As New Street was now an underground station, the King's Cross disaster of November 1987 raised concerns over the risks of a major fire, so it was created as a means of escape. In the light of ever increasing passenger numbers, it then opened to the general public in the 1990s to ease overcrowding. An entrance was sited on Navigation Street.

The bright colours of the trains only serve to exaggerate the greyness of the structure which had initially appeared as quite a stylish addition to the station.

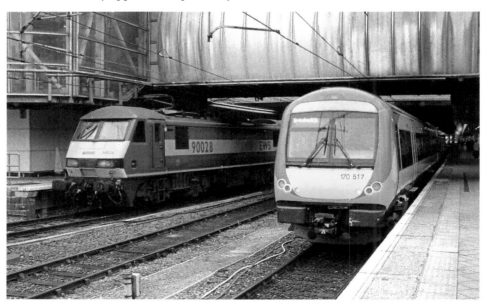

Stephenson Tower

Stephenson Tower, located off Queens Drive and close to the junction of Station Street and Hill Street, would prove a major headache when demolition was required. Being so close to the station, any conventional means of removing the building could not be used. Instead, workmen had to demolish one floor at a time. Huge amounts of waste material had to be lifted down by crane to be taken away. By 2015, the site will be occupied by a John Lewis store.

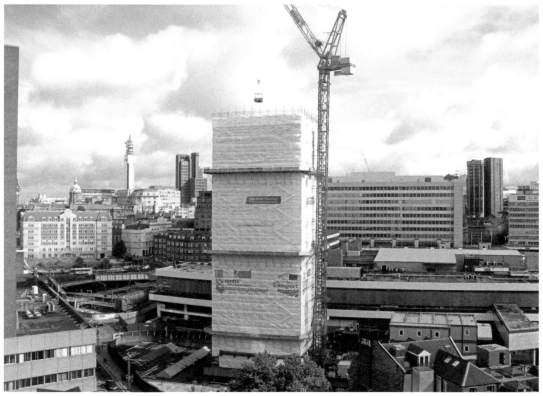

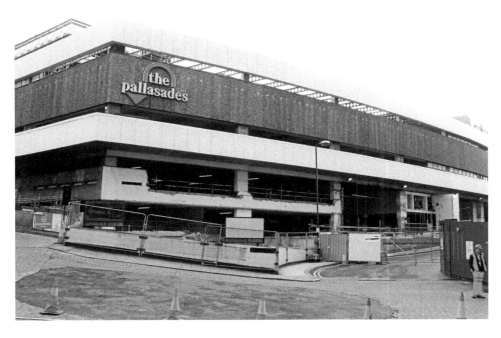

Gateway Plus

In 2010, a new project to transform New Street Station started. However, with passenger numbers at an all time high, the kind of major rebuild seen in the 1960s would not be possible. Adaptation and improvement would be the driving principles this time.

What had been a car park for the Pallasades shopping centre would be transformed into a new concourse ready for what was to become termed as 'Half Time Switchover'.

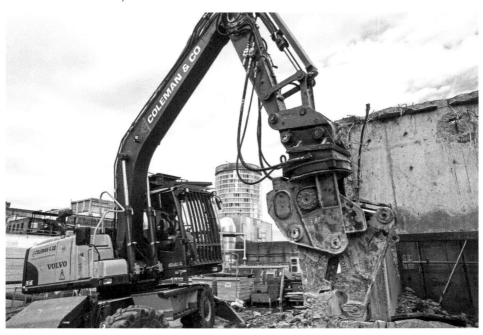

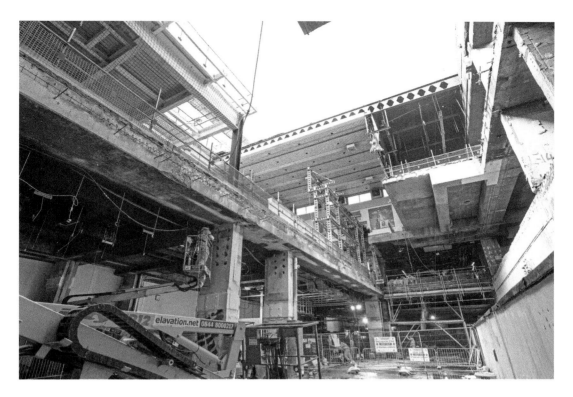

This rework was a massive engineering task and a team of over 1,000 workers were employed for the modifications to the car park and elsewhere on the site. Thankfully, the concrete structures were found to be in very good order and would provide a sound basis for the future of the station.

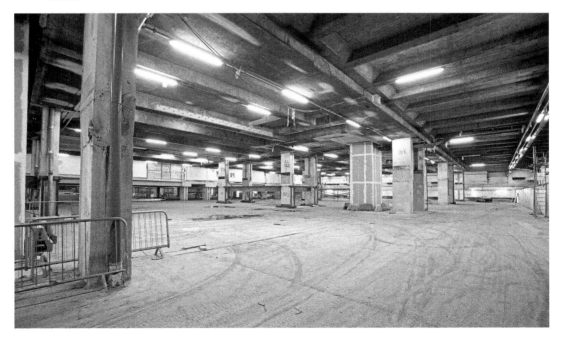

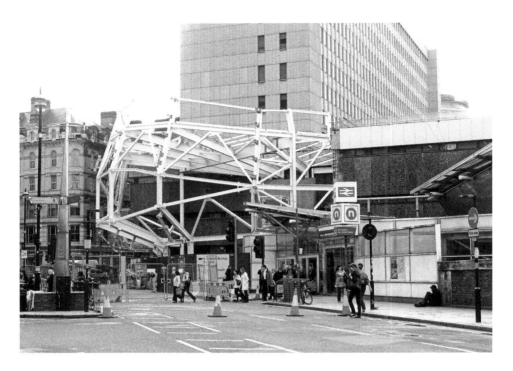

Cover Up

The plan for the outside of the station is a huge cover up. The drab concrete will be hidden rather than removed. In early 2012, huge, steel brackets started to be attached to the area around Stephenson Street. In all, 800 tonnes of bracketry will be needed for the whole project.

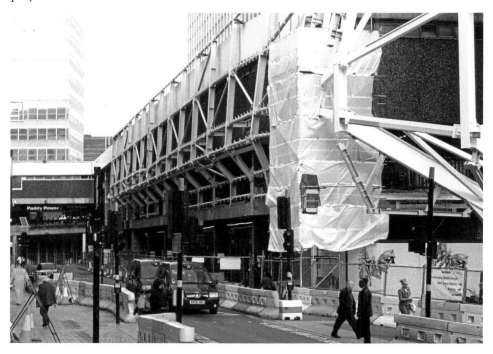

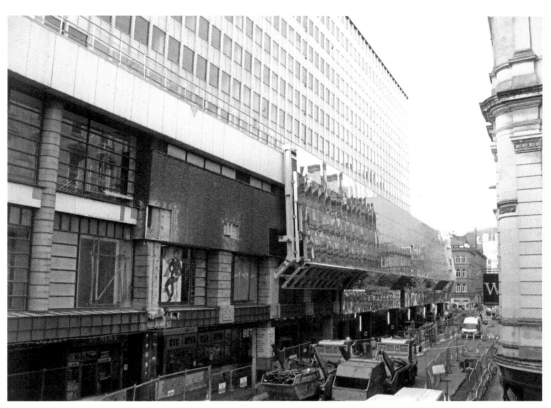

In early 2013, the stainless steel panels that will be the main feature of the new station started to appear. 300 tonnes of these, 8,000 unique panels in all, will be needed to complete the transformation.

Manufactured in Sheffield, the panels first appeared on the Stephenson Street elevation, close to the eye-like feature that marks one of the new entrances to the station.

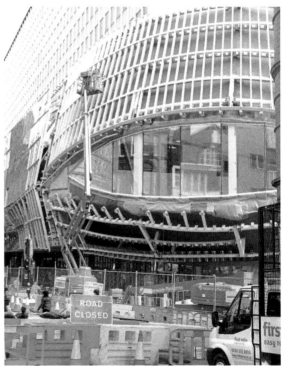

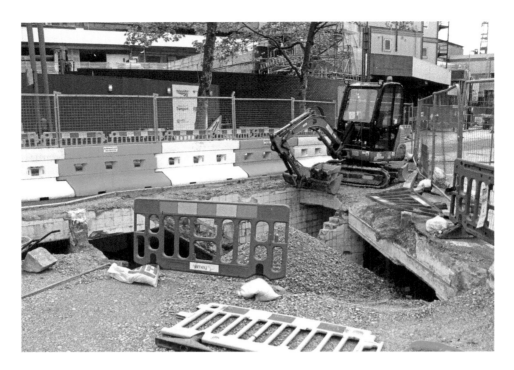

Station Street/Hill Street

At the junction of Station Street and Hill Street, the removal of Stephenson Tower allowed further demolition work to start. Here, another entrance to the new station will be created. Above this will be a new John Lewis store that will hopefully enliven this part of the city centre.

During the demolition, an old, underground gents toilet that had existed at this junction for many years was exposed, as seen above. In the past, this had simply been capped over and remained surprisingly unchanged before being filled with concrete in July 2012.

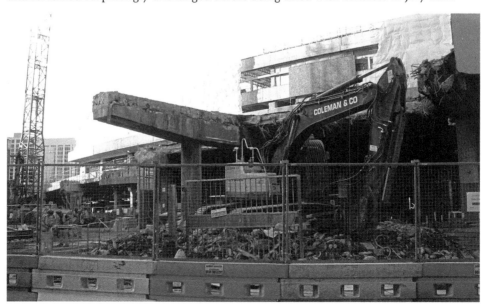

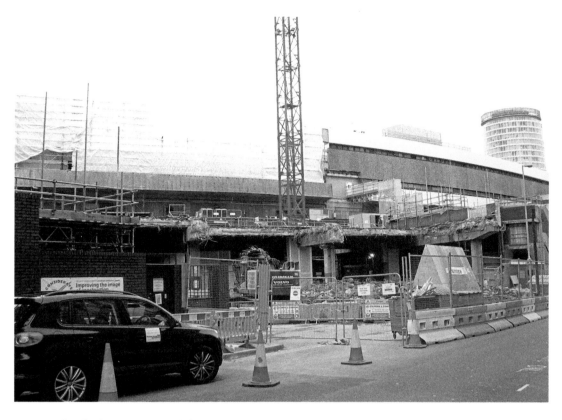

Right, the last remnant of the concrete steps that carried the right of way over the 1960s station, stands alone. As part of the Gateway Plus project, this right of way will be maintained and enhanced, a rewarding link with the past.

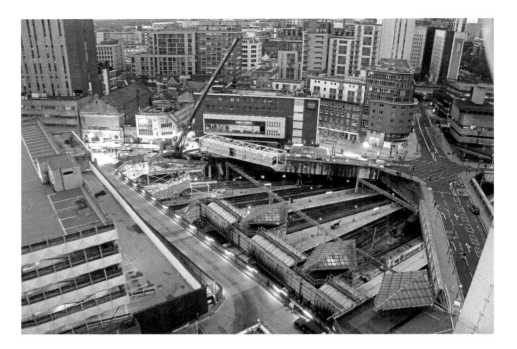

Footbridge Extension

December 2011 saw one of many major feats of engineering take place. An extension of the footbridge, added to the station in the 1980s, was craned into position. For the first time, this would allow access to platform 12 from the Navigation Street entrance. In future, it will also provide a new pedestrian entrance off Hill Street.

Like the rest of the station, the bridge link will be encased in stainless steel sheets, enhancing its drab appearance dramatically.

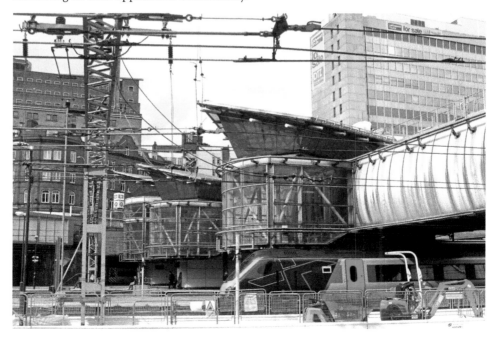

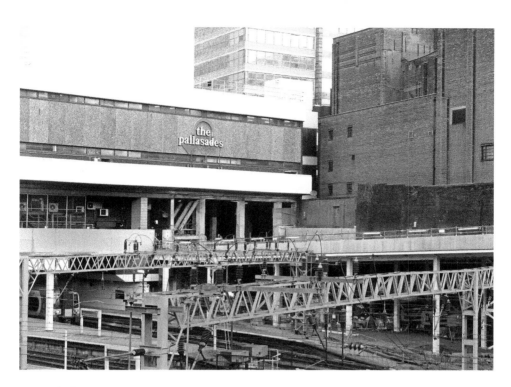

Pre-Switchover

April 2013 would see a number of major changes at the station. Most profound would be the closure of the main concourse. To enable passengers to move between Moor Street and New Street station, a new access link was created at the back of the Odeon cinema.

In addition to the closure of the concourse, the car park and taxi rank at the front of the station would also close.

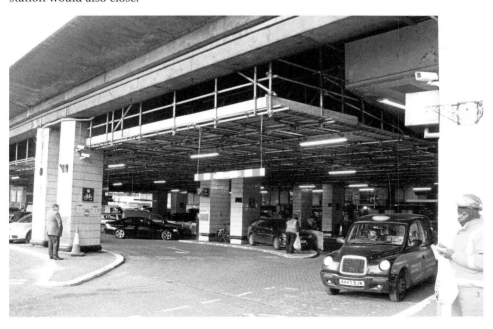

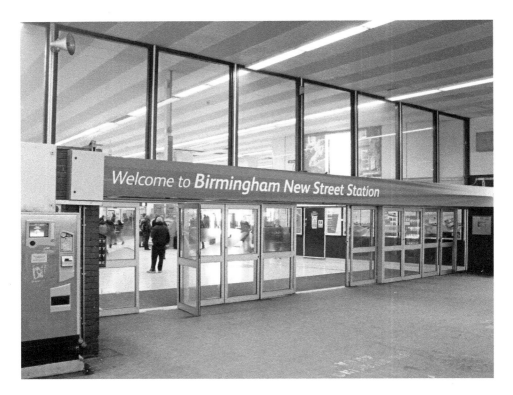

These scenes will be familiar to many a traveller, but have already become a part of the history of the station. The pedestrian entrance where taxis and cars dropped off passengers, and the ticket offices on the concourse, were little changed from when they opened almost 50 years earlier.

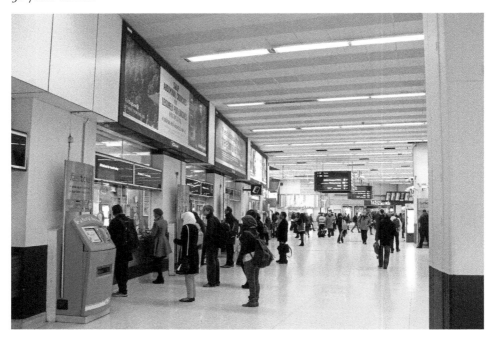

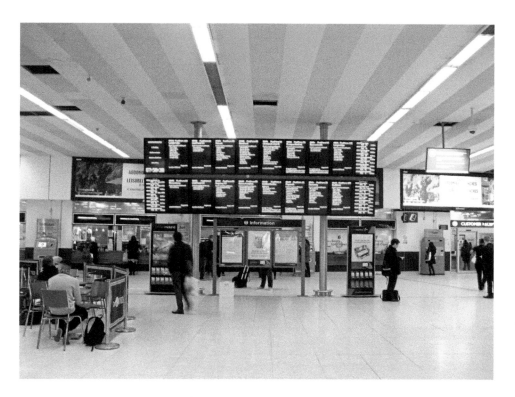

One improvement, made over the years, was the relocation of the departure board. No longer would passengers studying the board block those attempting to reach the platforms. But, apart from a few cosmetic changes, the concourse looked much as it did when constructed.

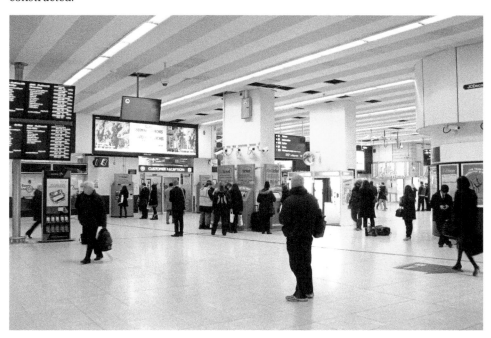

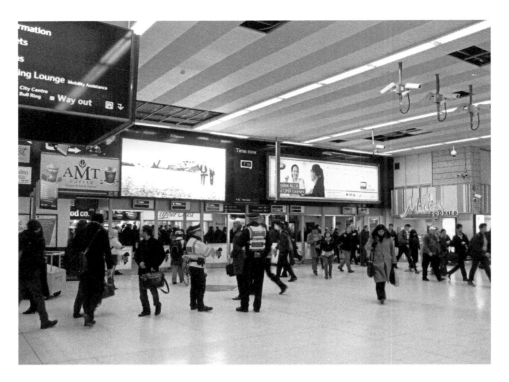

The busy access point to the platforms, above, sees police and CCTV much in evidence, a sign of modern times.

Below is the old walkway that led from Moor Street Station and the Bullring shopping centre.

Like some of the people in these pictures of the corridor providing access to the platforms, memories of this overcrowded and depressing feature of the 1960s station will soon be a blur.

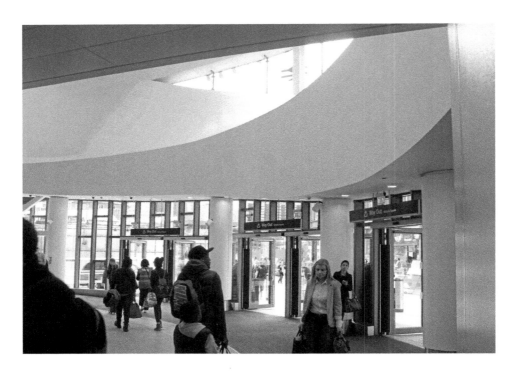

Post Switchover

28 April 2013 was the day of Half Time Switchover. For the first time, people could get an idea of how their new station would look.

Above is the entrance at the junction of Stephenson Street and Navigation Street looking very white and curvy. Curves seem to be a feature of the wide corridor leading down to the ticket offices and new entrances to the platforms. Although still lacking in daylight, modern lighting makes the new parts of the station far more welcoming.

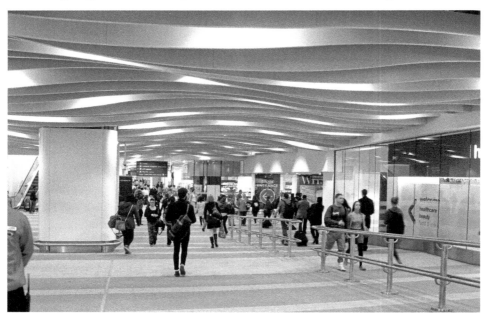

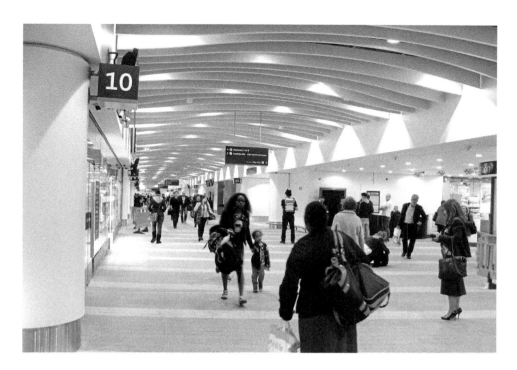

Once through the ticket barriers, the curved ceilings, stainless steel, high quality stone floors and white walls continue the themes already encountered. The general opinion was favourable, but confusion remained as some platforms could not be accessed via this new corridor.

Below are the temporary pedestrian and vehicular access points from Hill Street. A lack of facilities for taxi drivers caused to be a major headache in the months after the switchover.

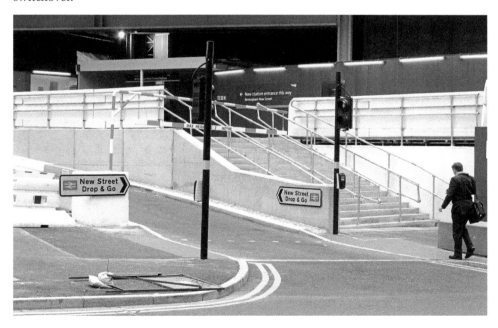

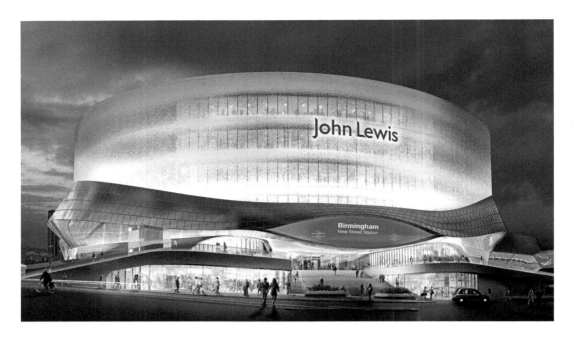

New Street, the Future Vision

The latest phase of New Street Station's long and varied history will be completed in 2015. Artist's impressions provide a vision of what that future will be like.

Above is the junction of Hill Street and Station Street. The John Lewis store that will sit atop one of the many pedestrian entrances will form part of a new shopping centre that will replace the Pallasades. This will be known as Grand Central in a nod to how the station was originally referred to back in 1854.

Below is the scene looking down Station Street towards Hill Street. Given the small drop off point, it appears that the finalised station may still attract the ire of taxi drivers.

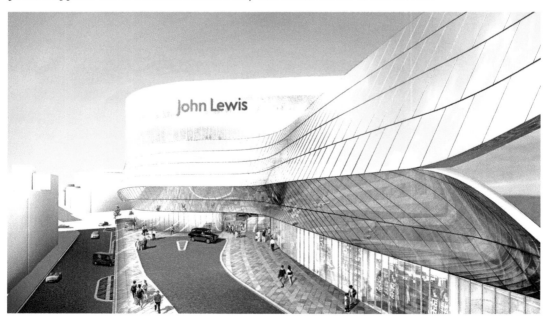

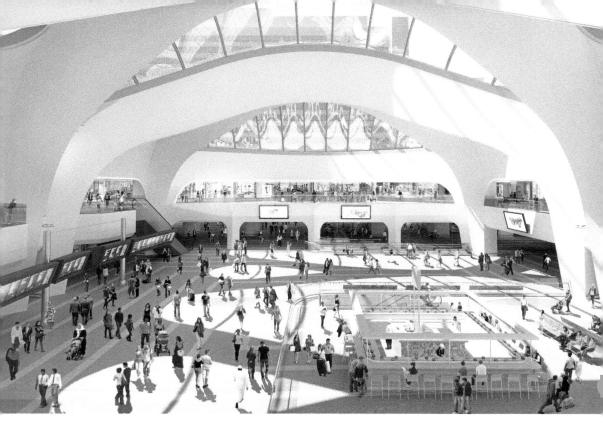

By far the most exciting feature of the new station will be the concourse and its spectacular atrium roof. At last, daylight will light up the area, brightening the lives of travellers as they pass through Birmingham. Some of this daylight will also make it down to the escalators that will provide access to the platforms. One of the light wells that will allow this can be seen in the centre of the picture below.

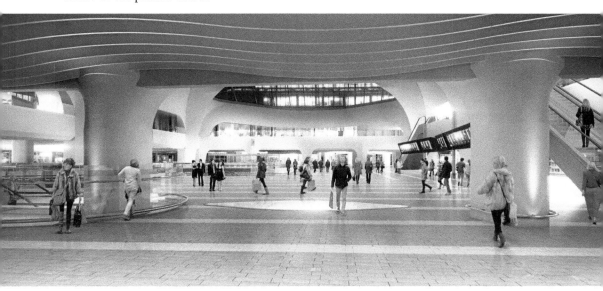

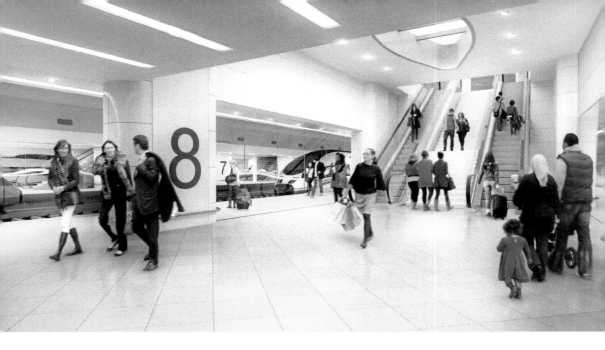

If the future of New Street's dark and dingy platforms even come close to the idealised view, above, it will be a huge improvement that will be appreciated by all those passing through the station.

With the re-introduction of trams servicing the station, it will almost be 'Back to the Future', as is indicated by the picture at the top of page 18. As part of the Midland Metro extension project, new lines will be laid from Snow Hill Station to New Street Station and should be operating by 2015. A further extension to Centenary Square has been muted, but is by no means certain.

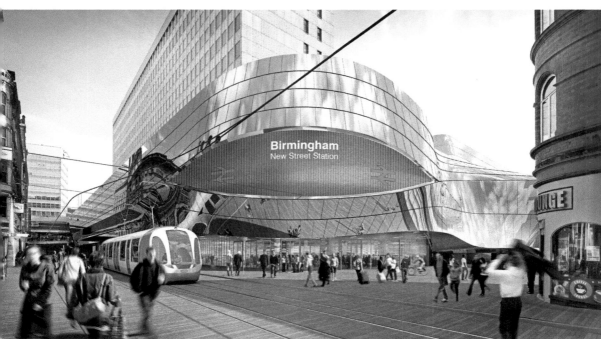

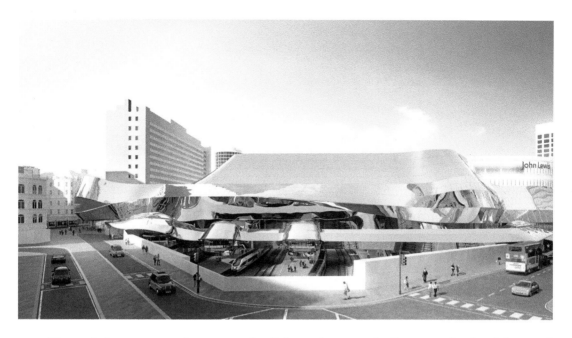

Views of the western and eastern ends of the station once the 8,000 panels of stainless steel sheets have been attached. Like the famous Selfridge's building that forms part of the Bullring, the new station is likely to be the subject of a love-hate relationship with city dwellers.

Below, the bubbles of glass in the centre of the picture mark the site of the atrium roof over the new concourse while the pedestrian walkway to Moor Street Station is visible to the right.

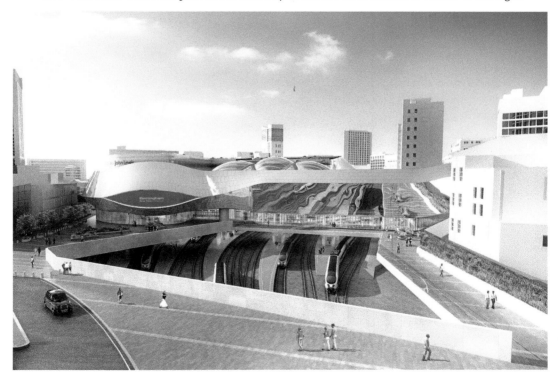

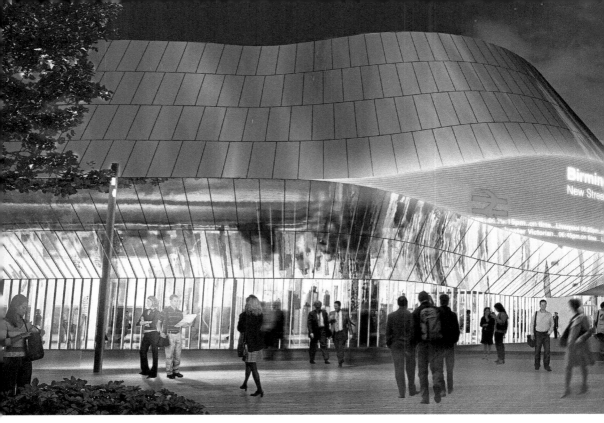

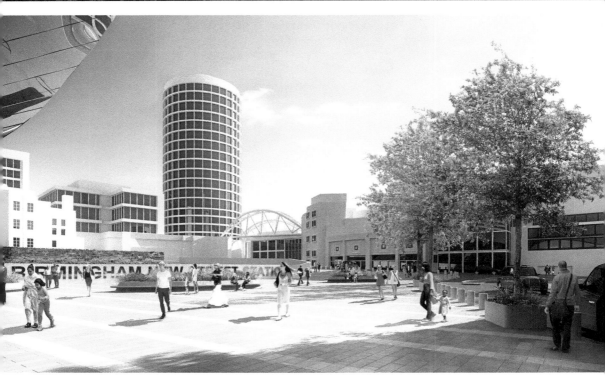

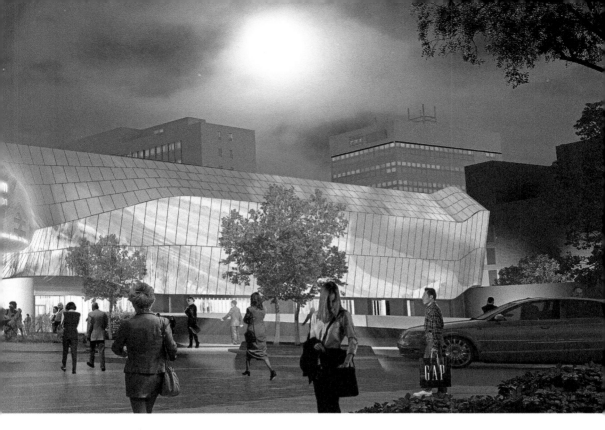

The vision for the area between the eastern end of the station and the Bullring shopping centre is an attractive, pedestrianised square. No longer will visitors have to fight their way past cars and taxis on their approach to the station, a positive change that reflects similar improvements elsewhere in the city. Modern planners do not follow the 'car is king' mantra of their 1960s forebears.

When the new station is complete, it will hopefully become an asset to the city. As happened with the improvements to the Inner Ring Road and Bullring, it may take a few years for the poor image of New Street Station to be removed from the nation's psyche, but it will be an important part of Birmingham's transformation. In time, it will become a part of the city that Brummies can become proud of.

Acknowledgements

A book like this is nothing without the pictures that help stir so many memories and excite the interest of the reader. For that reason, I am most thankful to all the following people who provided pictures for this book. In alphabetical order:

John Ball
Lauren Broadfield of Network Rail
Pat Dalton
Geoff Dowling, especially for the permission to use the work of Richard Law (snr)
Bob Essery
Pete Hackney
Julian Hammonds
Ben Herbert of Network Rail
Bryan Holden for permission to use the work of A. L. Hammonds
Marcus Kingsland
Mike Musson of www.warwickshirerailways.com
Michael Patterson
Michael Scott of www.photoaddiction.co.uk
Bill Stace for permission to use the work of his father, Leonard
Geoff Thompson
Andy York and the members of www.rmweb.co.uk

Many of the pictures from 1947–65 were taken by my late father, D. J. Norton, and more of his work can be seen on www.photobydjnorton.com.

Much of my research was via the Internet, a superb resource. I would like to thank all those that give their time to contribute to en.wikipedia.org. I would also like to thank Network Rail for making archive documents available at www.networkrail.co.uk/virtualarchive/new-street. Finally, mention should be made of www.newstreetnewstart.co.uk where progress on the Gateway Plus project can be followed.